"Corita's life and art has struck a sensitive cord in writer Sister Rose Pacatte. She does not shy away from telling the painful history of the courageous IHM Community—which is essential to Corita's story. Artistically and spiritually, Corita has always been my hero. Her life has influenced my teaching in so many ways—her love of the city, her celebrations of the ordinary, her sacramental visual theology. Pacatte understands the struggle of an artist in an institutional lifestyle. She presents a very vivid picture of a creative, joyful woman who has been an inspiration to so many."

—Sister Helen David Brancato, IHM
Professor of Art, Villanova University
Painter, Printmaker, Illustrator

"Corita Kent's story, from her childhood landscape to her journey, both spiritual and aesthetic is told in a linear, intimate, and unembellished style that draws the reader close through a clear lens. The writer's subdued affection for and admiration of her subject enables a nuanced understanding of Kent's likely inner dialogue. This influential artist and educator lived a complex emotional and philosophical existence, relayed as if one is being taken into confidence by a sister."

—Sarah Yuster
Artist, documentary filmmaker

"Corita Kent's art offers the sacred hidden in the ordinary. Rose Pacatte's compelling and balanced account of this significant modern artist's immersion into religious and public life reveals Corita as the sacred and ordinary woman she was. *Corita Kent: Gentle Revolutionary of the Heart* invites readers to view Corita's spirit-filled art with enriched understanding. Expect surprises."

—Nan Deane Cano, IHM

People of God

Remarkable Lives, Heroes of Faith

People of God is a series of inspiring biographies for the general reader. Each volume offers a compelling and honest narrative of the life of an important twentieth- or twenty-first-century Catholic. Some living and some now deceased, each of these women and men has known challenges and weaknesses familiar to most of us but responded to them in ways that call us to our own forms of heroism. Each offers a credible and concrete witness of faith, hope, and love to people of our own day.

John XXIII	Massimo Faggioli
Oscar Romero	Kevin Clarke
Thomas Merton	Michael W. Higgins
Francis	Michael Collins
Flannery O'Connor	Angela O'Donnell
Martin Sheen	Rose Pacatte
Jean Vanier	Michael W. Higgins
Dorothy Day	Patrick Jordan
Luis Antonio Tagle	Cindy Wooden
Georges and Pauline Vanier	Mary Francis Coady
Joseph Bernardin	Steven P. Millies
Corita Kent	Rose Pacatte
Daniel Rudd	Gary B. Agee
Helen Prejean	Joyce Duriga
Paul VI	Michael Collins
Thea Bowman	Maurice J. Nutt
Shahbaz Bhatti	John L. Allen Jr.
Rutilio Grande	Rhina Guidos

More titles to follow . . .

Corita Kent

Gentle Revolutionary of the Heart

Rose Pacatte

LITURGICAL PRESS
Collegeville, Minnesota

www.litpress.org

Cover design by Stefan Killen Design. Cover illustration by Philip Bannister.

1 2 3 4 5 6 7 8 9

Library of Congress Control Number: 2016962949

ISBN 978-0-8146-4662-5 978-0-8146-4686-1 (ebook)

*This book is dedicated
to the Immaculate Heart Community today
and to all women religious past, present, and future
who live love and mercy in their lives
even when no one is looking.*

Contents

Acknowledgments

There are so many people who contribute to a book that it is impossible to thank everyone but I would like to try. Special thanks to the Corita Art Center in Los Angeles, especially Ray Smith and Keri Marken and staff for their kind assistance and to Anna Maria Prieto, IHM, archivist for the Immaculate Heart Community. I am grateful to Nan Deane Cano, IHM, for permission to quote from her book and her availability to sit for an interview; to Lenore Dowling, IHM, Hermine Lees, IHM, and Helen Kelley, IHM, for their willingness to talk to me about Corita, as well as to Sasha Carrera and Mickey Myers for their assistance through the writing and research process. I am grateful to the helpful staff at the Schlesinger Library at the Radcliffe Institute at Harvard University for access to the papers of Corita Kent.

Thanks go out to Ian Berry and Michael Duncan and Skidmore College's Frances Young Tang Teaching Museum and Art Gallery for permission to quote from their book on Corita, to author April Dammann for talking with me about aspects of Corita's life that I continue to wonder about, and to Mother Mary Anne Noll, OSB, for sharing her memories. To Joan Doyle goes a special thank-you.

I am most grateful to my Daughters of St. Paul community in Los Angeles that always supports me. I could never have

completed this book without my sister Libby Weatherfield and her husband, Tracy; their dogs Petunia and Buster, rescue donkeys Buttercup, Daisy, and Harold; the chickens and random wild turkeys; and the roving nighttime skunks and coyotes for sharing their home in the foothills of the Sierra Nevada so I could have a quiet place to write as well as some interesting antics, smells, and sound effects. I think Corita would be pleased.

List of Names

Because many of the sisters named in the book had names given them in religious life and who either returned to use of their baptismal names or left the Sisters of the Immaculate Heart of Mary and married, this list may be helpful.

Sister Mary Corita, Corita, Frances Kent
Sister Mary William, Helen Kelley
Mother Mary Humiliata, Anita M. Caspary
Sister Mary Lenore, Lenore Dowling
Sister Marie Fleurette, Liz Bugenthal

Dance of the Universe

Passionate Presence,
dance your vibrant life within me,
Leap and bound joyfully through me.
I yearn to e centered and alive
so I can join the dance of the universe.
Help me to enter into greater oneness
with each and every part of creation.

Fill me with your enlivening vision
until I fully know that I am a sister
with all that roams, and wings, and swims.
Let your dance come bounding in me
so the trees' green springs in me,
songbirds singing becomes my singing,
the hum of the stars echoes as my hum,
lapping lake waters wash the shore in me,
and flowers' blooming tickles my soul.

Dance, Sophia, dance!
Urge my single heartbeat to join
with the ancient and ongoing heartbeat
of all that takes shape in this universe.
I long to dance your dance.

Joyce Rupp

Introduction

The Sisters of the Immaculate Heart of Mary (IHM) founded Immaculate Heart College in 1916 in Los Angeles; by 1947 it was becoming known as having one of the finest art departments in the country. *The Tidings* (now *Angelus News*), the newspaper of the Archdiocese of Los Angeles, reported in an October 10 article that year that additional faculty and curriculum offerings had been added—five new studios for painting, general design, costume design, weaving, and ceramics had been combined to form an art department of which the small college was rightly proud. The college now had three art majors: painting and commercial art, interior decoration and costume design, and teaching of secondary school art.[1]

But little did the Immaculate Heart of Mary sisters know that one of their own, Sr. Mary Corita Kent, a name that perhaps meant "little heart," would go on to become one of their most revered teachers and a world famous silkscreen (serigraph) artist when she was assigned in 1947 to assist Sr. Magdalen Mary Martin in the art department. In 1951 Corita had completed a master of arts in art history at the University of Southern California in Los Angeles and had begun to experiment with serigraphs. When she started winning awards in 1952 for her modern Byzantine-influenced serigraph *the lord is with thee,* even Corita didn't know that

1

her art on the West Coast would morph and emerge in the sixties as part of the pop art revolution that Andy Warhol was leading on the East Coast.

Sister Mary Corita Kent would eventually leave her religious community, exhausted and overcome by years of work. It was during the upheaval of the post–Vatican Council II world (and the IHM Community in particular), a world of war and social unrest. She would also quietly walk away from her Catholic faith. At age fifty and after thirty-two years of religious life, Corita began the next stage of her life.

Why, you may ask, would a Catholic publisher discern and decide to include a biography of Corita Kent in its "People of God" series, biographies that showcase Catholics, living and deceased, some even beatified and canonized, who led and are leading exemplary Catholic lives?

And why would I, who entered the religious congregation of the Daughters of St. Paul the summer before Corita Kent left hers, want to write it?

The overarching reason for this account of the life of Corita, as she became known—jettisoning even her last name when "Corita" became a brand—is that we have celebrated the Year of Mercy. Every family and every person in the pew has a family member or knows someone who has walked away from his or her Catholic faith and loves that person still as God does. Each person is on a journey toward God, even if the journey is unacknowledged or unwanted. And each person has something to teach us about being better human beings if we are paying attention.

And then, sometimes people just get tired.

In addition there is the incredible contribution that Corita Kent made to the world of art, indeed to fine art and to culture, that remains with us today. Her ways of seeing and making us look and pay attention to the people and needs of the world and how we are connected are the stuff of

legend and an ongoing education of the spirit. The "Someday Is Now: The Art of Corita Kent" exhibition that was originally organized by the Frances Young Tang Museum and Gallery at Skidmore College, New York, and shown at the Pasadena Museum of California Art in 2015, was for me an immersion into all things Corita.

On a personal level, as I learned more about Corita from articles, correspondence, books, films, her art, her own words, and interviews with people who knew her or know a lot about her, I discovered that she suffered from insomnia for decades, something that as a person with multiple sclerosis, I understand. She admits that "it had all become too much" as that summer of 1968 approached. I think Sr. M. Corita Kent was exhausted in body and weary in soul when she asked for a sabbatical from which she never returned. Her story evokes my empathy.

It was a privilege to research her papers at the Schlesinger Library on the History of Women in America at the Radcliffe Institute at Harvard University, meticulously ordered by Mickey Myers. While the papers were all about her, they reveal that she had a minimalist sense of self. There are loving letters from her brother Mark, written in his own calligraphic style, thanking her for monetary support using coded language; letters from her friend and artistic executor of her estate, Mickey Myers, who complains to Corita that she doesn't "get" Flannery O'Connor from the book of her letters that Corita had suggested she read; and almost nothing from her beloved sister Mary Catherine or other siblings.[2]

All the correspondence is one-way except for a couple of small, brief messages that made their way back to her and she decided to keep. There are two handmade books of art that students had made and she kept. There are many letters, written and typed, as well as scribblings in margins of articles from her great friend Daniel Berrigan, SJ. The letters

are warm, light, admiring, and complaining in his inimitably witty double-edged style about the authority figures in his life, asking Corita to design something for what he had written. And there are letters from corporate leaders who commissioned her after she went on her own and letters that reveal the small amounts that galleries wanted to pay her and other artists for their art.

The most telling contents of the *Papers of Corita* are two calendars she kept toward the end of her life as she struggled against ovarian cancer. She was not totally consistent in making notes in the small squares laid out month by month, but they reveal a woman who wanted to live, who walked and followed a strict diet, who was called back to her desk to answer and write letters and tidy her desk (one gets the impression that tidiness was a challenge for her!), and to continue to create art.

What is missing from Corita's papers, and understandably so, is any reference to the disagreements between Cardinal James Francis McIntyre of Los Angeles, Corita, and the IHM Community. In fact there are few letters from women she knew in her convent years. I believe that in order to understand more fully what happened to the Sisters of the Immaculate Heart of Mary and the choice that Corita made for herself, it is necessary to include this history in the chapter titled "Heavy Heart." It is shameful that a religious community of papal right was subjected to what the IHM sisters suffered—thirty years later the church apologized. These were and are valiant women. Corita, "little heart," was stalwart to the end.

The artist Ben Shahn (1898–1969) impressed by Corita's art, especially her work with typefaces, once called his friend Corita a "joyous revolutionary." Taken alone it would seem that Corita was a rebel. Corita was, only and always, an

artist who told the truth as she saw it in the world around her. She knew words have power, even words on a colorful silkscreen print.

Although this book is about an artist, no illustrations are included, except the cover which was drawn from a photograph by British artist Philip Bannister. You can use your imagination or go to Corita.org to see some of her art and order books and films about her. But look closely at the cover art. Let your eyes look into Corita's blue eyes and follow her gaze. What is she looking at? What does she see? What does she know that we do not? See and contemplate the hint of her smile. What is she thinking? As you read the book, return to the cover and imagine Corita.

Corita said a course in Catholic social teaching that she took in 1963 filled a void in her intellectual life and brought her a new awareness of social justice.[3] Taken with her growing awareness of the clash between the human person and consumerism and the blight of war and struggle for peace, this social teaching greatly influenced her serigraphs.

Though Corita Kent was dispensed from her vows by the Vatican and she quietly walked away from the practice of her faith and her church, neither her religious community, the church, nor God ever walked away from Corita. Nor does God walk away or abandon any of us or our loved ones on our earthly, human journey. Corita engaged in the mystery that surrounded her. Corita believed in hope as much as she believed in love.

Sr. Rose Pacatte, FSP
September 1, 2016
Jubilee Year of Mercy

CHAPTER ONE

Little Heart

"Love is here to stay and that's enough."
—The Beatles,
"Things We Said Today," 1964

Corita was born Frances Elizabeth Kent, the fifth child
and third daughter of Robert Vincent and Edith Genevieve
(nee Sanders) on November 20, 1918, in Fort Dodge, Iowa,
just after the end of World War I. Her mother was a thirty-
four-year-old housewife when Frances, or Frannie as she
was called in the family, arrived. Her father was born in
Wisconsin and her mother in Nebraska. Robert Kent was
a farmer but, according to Corita's birth certificate filed on
November 26, Robert was working for his father-in-law's
furnace company at the time.[1] Corita was preceded by Ruth,
Mark, Robert, and Mary Catherine and followed by Rich-
ard. Robert's parents were born in Ireland. Edith's father
was born in Holland, and her mother's background was
French (Chartres) and French-Canadian.

Corita's family tree lists at least two cousins of her gen-
eration who became religious besides her and Ruth (1912–
2004), both of whom entered the Immaculate Heart of Mary

Community. Their brother Mark entered the Maryknoll community and was ordained but later left and married.

When Corita was not yet two years old, the family moved to Vancouver, Canada, where Robert worked in the restaurant owned by his brother. Before Corita was of school age, the family went to Los Angeles by ship and moved into a multifamily housing unit owned by Edith's parents who had since moved to Hollywood and purchased property there. The Kents were poor, and Hollywood was, as Corita once described it, a sleepy town. The family lived at 6616 De Longpre Avenue between Seward and North June streets. In an oral history she recorded for UCLA, Corita said that there was a small park across the street where movies were often filmed.[2] De Longpre Park is still there today.

School Days

Corita and her family belonged to the nearby Jesuit-led Blessed Sacrament Parish on Sunset Boulevard. Many Catholics of Hollywood's golden era between the 1920s and '50s attended Mass there, including Irene Dunn, Bing Crosby, Loretta Young, and Ricardo Montalbán. Famed director John Ford paid for the grand bronze doors of the church.

Blessed Sacrament School, which Corita and her siblings attended, had the junior high system that ended with the ninth grade so Corita started high school in her sophomore year. She followed her older sisters to Los Angeles Catholic Girls' High School on Pico Boulevard that was still relatively new, having opened its doors in 1923. The school was re-named Bishop Conaty-Our Lady of Loretto High School in 1989 as a result of a merger. The Catholic Girls' High School had been dedicated in memory of Bishop Thomas J. Conaty (1847–1915) who headed the Monterey–Los Angeles Diocese

from 1903–15. It was the very first Catholic high school built in the archdiocese to serve the girls of Los Angeles. Our Lady of Loretto High School, opened in 1949, was the first high school for girls built under Cardinal John Francis McIntyre's ambitious post–World War II archdiocesan building program. The school was partially staffed by IHM sisters, and it is highly probable that due to her family's limited means that the school subsidized Corita's tuition.

Corita knew her simple neighborhood well and Hollywood that surrounded it. There were movie theaters and many radio and film studio offices in the area during her school days. When she walked to and from school, none of the billboards were present that would later become so important to her work in the sixties.[3]

Corita loved learning and reading as a child, and her interest in art began at a young age. She enjoyed making paper dolls, designing their clothes, as well as drawing. She made posters early on for school events. Her parents, especially her father who was a pianist and a skilled calligrapher (as was her older brother Mark, which is evident in his letters to Corita), always encouraged her.[4] Both of her parents were artistically inclined. When she was in sixth grade, one of the nuns who taught her, Sr. Noemi Cruz, IHM, was taking art classes at UCLA. Noticing Corita's interest and talent, she began to share what she was learning with the young girl after school.

But art education was not so great in high school where an elderly nun just had sophomores copy things using pencil. The next year they used charcoal, then pen and ink. Corita remembered her father asking her, "Why don't you do something original?"[5] She admitted that it had never occurred to her until then. She learned discipline from the copying approach but not much else and later said that the copying

method was a terrible way to teach art to children. The house had little art in it except for framed pieces of Corita's own high-school art. Corita believed her father saw her potential and noted that he could have been a poet but was burdened with his large family. He became an alcoholic and died at the age of fifty-six. Her mother lived in the family home and managed the rental properties there until she died in 1964.

Corita's high school report card (all three years are on one card) show that she was a good student with no marks for art in tenth grade but with all As in her junior and senior years except for one B+. Her grades for conduct were all Bs and B+s except for one C in her sophomore year, and one wonders what caused that dip. Her marks for English, which would become important to her, were mostly Cs and a few Bs despite her voracious love for reading. She did surprisingly well in Latin throughout high school with a strong B average. The only D she ever received was for civics in the last quarter of a one-semester course of her senior year. Her marks in religion ran from C+s to a single A in tenth grade. Her final religion grade before graduation was a B. Except for art, her high school years were academically somewhat better than average, but unremarkable overall. During her three years at the Los Angeles Catholic Girls' High School she missed seventeen days, seven of them in her senior year. She was tardy eighteen times. It's hard to interpret what a report card means in the day-to-day life of a student, but from Corita's we know one thing for sure: her interest and focus was on art.[6] She remarked later in life that she was often bored in school, and this made her want to be a better teacher.

Corita, quietly planning to enter the Immaculate Heart congregation, graduated from high school in 1936 and took art classes that summer at the Otis Art Institute in the Westchester neighborhood of Los Angeles, near what is now the

Los Angeles International Airport (it was called Mines Field until 1937).

That summer of 1936 had been hot and dry in Los Angeles, but the heat reached record-setting levels throughout the Midwest, adding to the human misery of the country's dust bowl. At that time the United States was inching its way out of the Great Depression with unemployment still at 11 percent, down from a high of 25 percent in 1933. Nazism was on the rise in Germany; in February FDR signed a second neutrality act while in May the Dutch Catholic bishops forbade membership of the faithful in the Nazi party. In April anti-Jewish riots occurred in Palestine, and in May Italy invaded Ethiopia. That same month Alan Turing published his paper on computable numbers that laid the theoretical foundation for modern computers (and would later lead to the breaking of the German Enigma Code that helped to end World War II). In June the Empire State Building broadcast a television transmission to experimental receivers; Pope Pius IX issued his encyclical letter *Vigilanti Cura* (On Motion Pictures); and Margaret Mitchell published *Gone with the Wind*. In July the Spanish Civil War began. In August Adolph Hitler opened the summer Olympic Games in Berlin and Jesse Owens earned his fourth gold medal for track.

Now almost eighteen years old, Corita, the budding artist, was about to enter the convent. She was of diminutive stature, little more than five feet tall, with brown hair and blue eyes that opened wide to look directly at those with whom she spoke. One source says that she never weighed more than ninety-eight pounds. Throughout her life she was always described as trim and youthful. A *Newsweek* article noted in 1967 that she had an "infectious vitality."[7]

Corita would need that in the years to come as an IHM sister, teacher, woman, and artist.

CHAPTER TWO

Heart in the City

"Jesus never fails."
—1967

Corita's decision to enter the convent on a hill overlooking the city of Los Angeles was, in her own words, a "well-guarded secret."[1] She surprised some of her friends and "utterly shocked" her closest friend when she announced she would follow her sister Ruth, older by seven years, into religious life as a sister of the Immaculate Heart of Mary at the end of the summer (their brother Mark was already a Maryknoll priest). Three of her friends became Immaculate Heart sisters as well.[2] Asked when she decided, she said, "I don't know. I think I just have always wanted to be."[3] According to Corita hers was a typical Catholic family and her parents were pleased that three of their children had chosen religious life.

The Immaculate Heart motherhouse stood on the side of a hill on several acres at the corner of Franklin and Western avenues not far from the Kent home, maybe two miles as the crow flies. The motherhouse was located in the neighborhood called Los Feliz on the northeastern edge of Hollywood, south

of Griffith Park with its famous observatory with the Hollywood sign above and the Hollywood Hills to the west. To the east was Atwater Village (named such because of its nearness to the Los Angeles River) and to the south was what has become the neighborhood of Little Armenia. The original motherhouse was demolished in 1971 due to earthquake damage, and the American Film Institute is located in what was once part of the Immaculate Heart College that closed in 1980. Today the Immaculate Heart High School (founded in 1906) and Middle School continue their long legacy of educating girls in the Archdiocese of Los Angeles on the same property that is also home to the Corita Art Center.

As young women did before her, Corita entered the convent in August, 1936, probably on the Feast of the Immaculate Heart of Mary. As a new postulant, Corita would have been welcomed with the characteristic joy and hospitality of the Immaculate Heart sisters. She would have joined with other postulants in bidding their families farewell, donning the required black uniform and mantilla veil, and beginning their spiritual formation as future Immaculate Heart of Mary sisters.

Did Corita and her family take streetcars to the stop nearest the convent that warm September day? Or did they drive a car? Who met her at the convent door? Was her sister Ruth allowed to? What sentiments and motivations did Corita express when asking to become a member of the Sisters of the Immaculate Heart of Mary who had been her teachers at Blessed Sacrament School and in high school?

We cannot know the details of that day. Nor can we know the specific reasons Corita articulated in a letter asking to enter the Immaculate Heart congregation. As with every religious congregation, a young woman who wished to enter the sisters of the Immaculate Heart of Mary had to fill out

a form asking about her family, education, dates she was baptized and confirmed (with copies attached), and obtain a letter of good health from a doctor and a reference letter from her pastor, at that time Cornelius McCoy, SJ.[4] Most of all she had to write a letter to the mother general indicating her desire to enter. She was then required to write again to be admitted to the next stages of formation: novitiate, first vows, annual renewal of vows, and final vows. These letters were kept in a private file for each person, preserving the story of each sister as a precious legacy. These files are private and no one would ever have access to it except the archivist, even for an author writing a biography.

Corita destined her papers for the Arthur and Elizabeth Schlesinger Library on the History of Women in America at the Radcliffe Institute at Harvard University. Corita asked Micaela "Mickey" Myers, an artist, close friend, and former student, to be the artistic executor after her death. Myers attests that every paper found in Corita's apartment at her death are in her files at the Schlesinger; nothing was left out.[5]

Later in life, long after she had left the IHMs, she said that she entered the community because she loved the women who had taught her in school, who were IHM sisters. She called them wonderful people and excellent teachers, "splendid" women.

Corita did have an interview with the mother general, at that time Reverend Mother Redempta Ward, before entering as all candidates did, and she would have been asked again about her motivations. Her response must have met with Mother Redempta's approval as Corita was accepted. Postulants spent most of the time cleaning, dusting and polishing, and pinch-hitting as teachers in the classroom as needed. On her reception day and entrance into the novitiate on February 11, 1937, Corita and the other postulants wore

white wedding dresses to receive the blue serge habit and woolen scapular of the Immaculate Heart sisters. She asked for and received her new name: Mary Corita. It is thought that the name means "little heart" in Latin but no one is really sure where the name came from except perhaps from the sister's devotional heritage as IHM sisters. She would never again be known as Frances or Frannie.

During her novitiate Corita and the other novices would have kept to themselves in a restricted part of the mother-house; they were not allowed to speak to the professed sisters. They would have studied the community's Augustinian-based spirituality and the history and constitutions of the institute. There was a strict prayer schedule and a study of Fr. Adolph Tanquery's *The Spiritual Life: A Treatise on Ascetical and Mystical Theology*[6] and other spiritual books in the novitiate library, according to Anita M. Caspary (Mother M. Humiliata) who entered in 1937, a year after Corita.[7] The novices of that time were also required to memorize "The Catechism of the Vows" before they would profess their vows.[8] There were few visits from her family and no mail was allowed during that year. In the evenings the novices would gather to converse and tell stories and on holidays and weekends, especially, would play tennis and basketball. Sometimes they would take walks in the neighborhood and stop to munch on snacks they took with them.

Although the novitiate was a time apart, Corita had been teaching since she entered the convent and taught during the novitiate too. She says she got her start as a teacher in a very "rough" way without any training and only a high-school education. It was unusual for the novices to be asked to teach because the formation stages of postulancy and novitiate were reserved for spiritual formation. Yet some-times a response to the needs of the apostolate were included

as preparation for the life Corita and the novices would lead once they professed their vows.

Corita pronounced first vows of poverty, chastity, and obedience on February 12, 1938, and started studying at Immaculate Heart College for a bachelor of arts, perhaps that very summer. Like most Immaculate Heart sisters, she continued teaching during her college years, studying at night and on weekends. This was not an easy thing to do as the young sisters, prepared or not, were working full time as teachers and had a strict 10:00 p.m. lights-out rule, though some sisters would turn out the lights for five minutes then turn them on again and continue working or preparing for classes. Corita most certainly did because insomnia was becoming her constant companion.

She encountered the German art historian, museum director, critic, and scholar Alois J. Schardt (1889–1955) for the first time during her undergraduate years in the art history courses he taught at Immaculate Heart. She thought him one of the greatest men she had ever met.

Corita graduated from Immaculate Heart College in 1941.

Teaching Years

After her graduation Corita taught elementary school and art to various classes at Our Lady Queen of the Angels (La Placita) school in the Chinatown neighborhood of Los Angeles and art in the high school. Both schools are now closed.

In 1944 Corita was sent to teach primary school in Canada. The community of four sisters lived at Sacred Heart convent on Brentwood Bay on Vancouver Island and Corita taught at three schools over three years. She first taught for a year and a half at Assumption school though some art classes were taught in a room in the rectory. Mission life wasn't always

easy. If for some reason the priest was unhappy with the sisters, he would just turn off the heat. She then taught at the Tsawout First Nation Indian primary school in Saanicton. Unlike many of the IHM sisters, she never had any desire to be a missionary but another sister had become ill and Corita was chosen as her replacement. Though she hadn't wanted to go to Canada, she was sad to leave when the time came.

As for being a teacher, Corita admitted that she didn't have a good opinion of her own intelligence and didn't think she could teach—yet, besides nursing, this was all the IHM sisters did. Corita, however, was innovative when it came to getting the children's attention and was always ready to help other teachers with "children's art experiences [and] would cut out fantastic animals and creatures for sisters to take to their classrooms."[9]

Later, Corita's assignments at the college level (for example, to make two hundred line drawings of one thing overnight) were inventive and forever memorable. Many students found them inspiring if not capricious; others found them unreasonable and frustrating; and one found them outrageous. She taught her students to see beyond themselves and recognize the connectivity of all things. She pushed her students to go beyond their own self-consciousness that could block their creativity. When asked several years after college, "What happened to you in the art department?" two students replied that Corita had saved their lives. Another said that Corita had given her life.[10]

She would also develop a synthesis of her thought on the philosophy of art and being an artist in Catholic education; her insights remain relevant today. Her very philosophy of life and spirituality is reflected in her art through the years.

During her thirty years in religious life, Corita's assignment within the community was to serve meals to priests

and bishops who came to visit, and this lasted well into the sixties. She is known to have been a religious who fulfilled all of her community obligations. Hermine Lees, who entered a few years after Corita, remembers her this way:

> She had a distinctive manner of speaking, an unusual laugh and definite gestures. She always engaged you. Even as she became "a superstar" she was generous, sympathetic and kind. She would stop and speak with you. I had Corita for art in the summer. She listened to each person who approached her; she would look at each person as they spoke. I knew she had insomnia and she must have been exhausted, but she listened. And she wanted us, her students, to learn how to be spontaneous, to relish creativity, to be aware of simplicity.[11]

Lenore Dowling, who would teach film in the art department under Corita's leadership beginning in 1965, remembers that:

> Corita had deep feelings. She had a persona as a teacher and a persona as a lecturer. Corita was extraordinary but in community she was just one of us. I remember that her assignment was to serve breakfast to the priest after Mass. She wasn't a leader or an outspoken rebel. Sister M. William (Helen Kelley) led the college with her intellectual insight but Corita had the insight of the heart. She led by example. She had a great respect for everyone, no matter who they were. She never had a preference for anyone.[12]

Nan Deane Cano, IHM, was a student at Immaculate Heart College from 1963–66 and shared a room with Micaela "Mickey" Myers who would become Corita's artistic executor after her death. Nan remembers Corita as

very accessible and friendly whether you were an art major or not; she was still and attentive. If you paused to talk she gently listened. She was solitary yet busy in the community. She would help anyone, she'd drop everything and help the struggling elementary school teachers looking for help. She did all the humble tasks that were asked of her.[13]

Another person said that if you asked Corita to pray for someone she would stop where she was, bow her head, and say, "Jesus."

It is important to know the context for Corita's life as a teaching sister of the Immaculate Heart of Mary in view of the events of the late fifties throughout the sixties that were marked by turbulence in the world, the Catholic Church, the community, and Corita's personal life.

The path of how any apostolic religious order, congregation, or institute comes to be is always unique.[14] The charismatic inspiration to bring together women to do the work of Christ as lived through his example of poverty, chastity, and obedience in the gospels is to respond to a need in the church and the world through works that reflect the corporal and or the spiritual works of mercy.

The story of the Sisters of the Immaculate Heart of Mary began in Spain in 1848. Father Joaquin Masmitja de Puig (1808–86) founded the semicloistered Daughters of the Most Holy and Immaculate Heart of the Blessed Virgin Mary of pontifical right. Its purpose was to build up society through catechesis of the poor and the education of girls. In 1868 the Spanish-born Bishop Thaddeus Amat (1810–78) of Monterrey-Los Angeles in California, on his way to Vatican Council I, passed through Spain and asked Fr. Puig to send sisters to his diocese. After travel delays caused by the Franco-Prussian War, ten well-educated missionary sisters headed by Mother Raimunda Cremadell (1824–1900)

traveled by ship to New York and then by train to San Francisco, arriving there on August 31, 1871.

Once in California, the sisters were unexpectedly divided into two groups by the bishop of San Francisco, Archbishop Joseph Sadoc Alemany (1814–88); simply because they landed there he claimed their services. They were not sent to Los Angeles but to Gilroy to staff a school and to San Juan Bautista to take the place of the Daughters of Charity of St. Vincent de Paul at an orphanage. Bishop Amat would have to wait.

Finally, almost fifteen years later on January 1, 1886, Mother Raimunda and five sisters (three of whom had entered the community in the United States) arrived in the port of San Pedro by ship from San Francisco to staff Catholic schools in the Los Angeles Diocese now headed by Bishop Francis Mora (1827–1905). Mora respected Bishop Amat's original vision for the sisters to educate children in the diocese to the point of deferring the offer of another community to come into the diocese. The sisters' first assignment was to teach at the newly built school at the Cathedral of St. Vibiana. The institute grew in numbers and took on new schools. Bishop Mora held the legal title to the property of all the institute's houses—and notified the Vatican that the sisters worked hard and were observant—and all the sisters considered *him* to be the provincial superior.

This independent streak did not go down well with the mother general in Gerona, Spain. Years of growth in California were accompanied by discord between Bishop Mora, along with the sisters in California, and Fr. Joaquin and the mother general in Spain due to the influence of the succeeding local bishops. Several issues aggravated the situation: distance, lack of communication, language, and differences over the level of the sisters' education. The American province,

now centered in Los Angeles, grew apart from Spain. After several years of unease, disagreements, and growing cultural disparity, Bishop John Joseph Cantwell (1874–1947) intervened and petitioned Rome asking for a separation. On March 15, 1924, a new Pontifical Institute was established, the decree from the Vatican leaving the charism of the community intact but asking for a slight change in the name and variation on the habit.

What is so interesting is that Bishop Cantwell, following the early lead of his predecessors, Bishops Mora, Montgomery, and Conaty, expected that the new institute would be under his jurisdiction as the local bishop, an institute of diocesan right. Instead, Pius IX established the new institute with papal right that the original order enjoyed, meaning that the local bishop had jurisdiction over normal matters but the pope directly or through the appropriate Vatican office (then the Sacred Congregation for Religious) had jurisdiction over the congregation.[15] Most important, the local bishop could not intervene in the institute's internal matters or change the constitutions (rule.) The sisters could retain the titles for their own property. For any dispute between the local ordinary and the congregation, the sisters would have the right to appeal to the pope, if it came to that.

It was to this newly established congregation of the Sisters of the Immaculate Heart of Mary that Corita joined just eleven years later.

CHAPTER THREE

Creative Heart

"After ecstasy, the laundry."
—Zen saying

Corita's development as an artist accelerated when she was called back unexpectedly from Canada in 1947 to assume a faculty position in the art department at Immaculate Heart College under Sister Magdalen Mary Martin. The college was going through the process of accreditation, and it was recommended that the art department have at least two instructors. Corita was selected to join Sr. Magdalen Mary because of her obvious artistic talent and that she had already accumulated some credits toward a graduate art degree.

The art department was located in what everyone called the "catacombs"—the gardens, fountains, practice rooms, classrooms, and offices at the street level in the now demolished building on Franklin Avenue.

Since Sr. Magdalen Mary had an art degree from the University of California at Los Angeles (UCLA), it was decided that Corita would go to the University of Southern California (USC) for a graduate degree in art history to have a

different learning experience. The prerequisites for the degree were many, and it could have taken her up to six years to finish. But an adviser took into account courses she had taken at the Chouinard Art Institute (where Walt Disney sent his animators to study) and one summer at Woodbury University, making it possible for her to finish more quickly. She admitted that she mostly went through the motions to get her master of arts degree and didn't meet any artists during that time that influenced her future work, though visiting art exhibits did.

After taking all the required courses by early 1951, Corita still had four elective units to finish. It was almost accidental that she became interested in the art of serigraphy, the noncommercial process of silk screening.[1] Serigraphy was just emerging as popular art right around that time, and she had acquired a kit and had begun to experiment with her students. Corita decided to use all her elective units for studio classes in screen printing. Since it was easier for her to work from home, she would only go to class to turn in her work—much to the amusement of her sisters in community.

The person who really taught her the screen-printing technique, however, was Maria de Sodi Romero, wife and widow of the famous Mexican muralist, Alfredo Ramos Martinez (1871–1946). Corita became well-known for using the Tusche resist process for her serigraphy. She started out using the photo emulsion process, but that gave her some problems when she tried to remove the image from the screen; she didn't have the right solvent. A student offered to bring in a woman (Maria) who knew screen printing. In one afternoon Maria taught Corita everything else she needed to know, and her art took off from there.

Corita's thesis for her master of arts degree was on "some medieval sculpture" that she says was "miserable"—the

thesis, not the sculpture. The title is: "An Evaluation of Romanesque Sculpture in a Study of the Four Causes of Its Being." Corita received her degree so she must have defended her thesis adequately, but one can only imagine how challenging it was for her to write.

Corita completed two prints during this period. A year later, in 1952, she looked at one of them and decided it was so bad that she started layering colors on top of it and making something completely new. In the oral history of her life, she recounted, "It turned into a completely different picture because underneath it was a picture of the Assumption, with a very, as I remember it, a kind of fashion-modelish lady in the center. It was a very unwhole picture."[2]

Public Life

Thus began Corita's public life both in academia and the world of art—and eventually into the larger culture. The "new" print, titled *the lord is with thee,* seems more of a modern riff on a Byzantine madonna and child, and it appears to have a holistic integrity to it that art judges saw even if Corita didn't. Corita or Sr. Magdalen Mary (the record is not clear) had entered it in the Los Angeles County Museum's art competition, and it took first place; the prize was fifty dollars. She describes herself as being "overwhelmed" by the award.[3] She then entered it in the California State Fair in Sacramento, and it won first place there too. Other awards followed.

After this, the art department began submitting student work for exhibition, and Corita's prints were included. At the exhibits, Corita and Sr. Magdalen Mary would trade prints with other artists, thus beginning a collection that would grow over the years.

With so much press coverage and notoriety, Corita began receiving invitations to speak on art. To respond, the energetic Sr. Magdalen Mary began to organize lecture tours during the Christmas break. Between 1956 and 1964 they traveled to various venues such as libraries, colleges, and museums, and Corita would give talks illustrated with slides. Their final destination was always New York where they would visit museums and the local art scene that was a year or two ahead of Los Angeles. The speaking fees, such as they were, paid not only the travel expenses but also financed purchases for the college's Gloria Folk Art Collection. By 1958 the two Immaculate Heart of Mary sisters had traveled to thirty-six states where Corita exhibited her prints and gave lectures.

Corita said that both of them were demons for work but thinks she was a little worse than Sr. Magdalen Mary.

There is no doubt that the college's art department was exploring new art forms, even pushing boundaries, from collage to stamp making (out of erasers), calligraphy, ceramics, mosaics, design, and folk art to teacher training in art. Corita said that the style she always returned to in her art was "loose forms and simplicity." She was attracted by Chinese and Irish calligraphy and started adding script to her work in the early fifties. Corita believed in the power of the written word as a meaningful art form; she believed that images and words were connected and belonged together, creating new, whole images. Her major influences during this time were the abstract expressionism of Robert Motherwell, Adolph Gottleib, and Mark Rothko. She also admired Paul Klee for "his connection with the world of the dream, the fantasy and his linear quality . . . his drawing and his playing around with drawing and the object."[4]

Corita's first specialty was serigraphy, and she designed and printed a series of original silk-screen prints each year

for sale to anyone for the benefit of the art department and the college. She loved the populist aspect of it, the nonexclusive nature of the art form that anyone could buy a copy of because costs were so low. For the twenty years she taught art at Immaculate Heart College, she would spend the only free time she had, the month of August, to work on a new series of serigraphs. Her work area was a rented space across the street from the "catacombs" in a storefront that is now a dry-cleaning business. Students and others would come to help her in various ways—some friends coming from across the country—and if they learned anything it was Corita's creativity, the speed with which she worked, and her work ethic.

Her own style of calligraphy—from serigraph posters and book illustrations to writing letters to adding names and phone numbers to the tiny paper (two inches by three inches) Hermes address book she used in the last years of her life—would debut in 1962 once she had encountered the pop art of Andy Warhol.

Sister Magdalen Mary was in charge of the art department and led with her philosophy: "Education is the by-product of the disinterested quest for all that deserves to be sought and loved for its own sake."[5] She organized the department, something for which Corita had no interest or aptitude. Sr. Magdalen Mary taught painting, mosaics, and eventually serigraphy, while Corita, by the sixties, taught courses called "Lettering and Layout," "Image Finding," "Drawing," "Art Structure," and various other courses with "imposing titles," according to Jan Steward who cowrote with Corita *Learning by Heart: Teachings to Free the Creative Spirit*: "It didn't matter what names they had. They were classes in Corita. She insisted, coaxed, demanded, and, in short, was a tyrant. She taught with the pull of a strong tide. Bit by exhausting bit we were pushed into an awareness of

the pulse and beauty of life around us and how to put them together to make our own life song."[6]

While Sr. Magdalen Mary was not an artist herself, she was an innovative teacher who loved mosaics and would eventually teach silk screening when the courses offered at the college expanded. Sometimes she and Corita would spend time together on a Sunday afternoon, pin up the students' work, and analyze it. Corita always recognized her colleague as a great teacher and learned much from her. A fine example of the depth of Sr. Magdalen Mary's artistic knowledge and sensibility is evident in a quote she gave to a magazine in 1963: "An essential difference between a painting and a mosaic lies in their respective responses to light. A painting uses light so that the observer may see the painting. When light becomes active over the surface of a painting, the picture disintegrates as far as the observer is concerned. In a mosaic, however, light is one of the essential and continually active elements. The mosaic-maker tries to control the light in such a way that it makes, not breaks, the design."[7]

Alexandra "Sasha" Carrera, who directed the Corita Art Center for ten years, described Sr. Magdalen Mary and her approach to teaching art: "She was a robust, iconoclastic character whose idiosyncratic teaching style focused on process and discovery rather than traditional techniques. According to the *Irregular Bulletin* (1959), she referred to student work as 'investigations in non-utilitarian areas' and it was she who encouraged and, by some accounts, pushed Corita's own artwork.[8]

Other artists who influenced Corita were the art historians Dr. Alois J. Schardt from Berlin and Paul Laporte from Munich. Both taught at Immaculate Heart College, Laporte succeeding Schardt in 1956 after the former's death. While Corita remained a friend and corresponded over the years with Laporte, she credits Schardt and Charles Eames, the

designer and architect, as the two key people who educated her because these men "had the ability to pass on concepts not just a string of facts."[9] Laporte interviewed Corita on her life and art after she left the community. She must have thought a lot about it for she transcribed the interview by hand, and it is in the collection of her papers in the Schlesinger Library today.

At the end of the day, however, Corita said that Charles Eames was her real teacher even though she met him after she completed her formal education. She often took groups of students to the home he shared with his wife, Ray, a home that Corita called "real art."

> He was not an art teacher, he was an artist who taught— taught by words, films, exhibits, buildings, classes, visits, phone conversations and furniture. . . . Hardly anyone has sat in an airport and not been held in one of his chairs or a chair influenced by his. His list of credits is long, his achievements always in the best sense educating. . . . From Eames or any of his works we learn to form outworn distinctions and separations and to see new relationships— to see that there is no line where art stops and life begins. He talked a lot about connections.
>
> Of his teachings I can hardly distinguish between what he actually said and did from what he taught me to say and do myself. His teaching is still living in me and I am still learning from that life in me, as well as from students and friends, and every single contact with people and things. He taught me that, too."[10]

Later Corita would credit Victor Frankl, Buckminster Fuller, Norman Cousins, and Robert Muller as influences.

In 1959 Corita and Sr. Magdalen Mary went on a three-month tour of Europe and the Middle East, paid for by one

of Sr. Magdalen Mary's benefactors. They visited galleries and met artists all along the way. Their adventures were published in the art department's newsletter, the *Irregular Bulletin,* started by Sr. Magdalen Mary, so-called because it was published only when there was enough time and money. A photo of the two women in full habits riding camels in front of a pyramid later appeared in *Artforum,* a magazine of contemporary art. Corita reportedly took eight thousand slides on the trip that she later used in her presentations and teaching, though this number may be inflated.

When they returned, the sisters continued teaching as usual but there was an air of excitement and expectation for the coming ecumenical council to be known as Vatican II that they knew would impact their life and mission as Immaculate Heart sisters. There was also a current of foreboding coming from the chancery office of the Archdiocese of Los Angeles aimed directly at Corita, the college, and the community.

Changing Styles

Andy Warhol (1928–87) is perhaps the most popular and well-known of the pop artists that emerged in the United States in the late fifties. Pop art flowed from and at the same time pushed back at abstract expressionism. By taking ordinary and mundane objects in modern life—often from commercial advertising and re-creating it outside the context in which it occurred—pop art reflected the artifacts of the dominant consumer mass culture and was ironic and subversive at the same time. Corita's transition from subjects influenced by religion to those that brought the sacred and the secular together began when she saw Andy Warhol's *Soup Cans* at the Ferus Gallery in Los Angeles in 1962. That summer she produced her first pop print *wonderbread* that

fused the colorful bread wrapper and the Host. A few weeks later on October 11, Pope (now Saint) John XXIII opened the Second Vatican Council in Rome.

In 1963 Corita was commissioned by her friend Norman Laliberté, to create a banner for the Vatican pavilion at the upcoming world's fair in New York in 1964–65. Corita accepted and painted three similar canvas banners each about forty feet long and four feet high, which were a modern rendering of the Beatitudes ("Happy are" instead of "Blessed are"). She chose one of them to display not far from Michelangelo's Pietà that the Vatican had sent for the duration. According to Ray Smith, current director of the Corita Art Center, the three pieces were painted in acrylic and some house paint. Corita worked in multiples and from an intuitive level. She was more free when she worked if she made more than one because then she could choose the best. She had also never made anything so big. The principal of the nearby Mother of Good Counsel School let Corita use the school's basement to create the pieces.

After the world's fair, the United Church of Christ acquired the one that was on display; they still own it today and have it in their headquarters in Cleveland. Another print published in the catalog *Someday Is Now: The Art of Corita Kent* is in a private collection. The Corita Art Center has the third; it hung above the food service in the dining room of Fullerton Junior College in California for a number of years and was eventually donated back to the center.

One day Corita's teaching was interrupted by a phone call inviting her to create a different kind of exhibition, this time for the 1965 Christmas window display at the IBM product display center at Madison Avenue and Fifty-Seventh Street in Manhattan. She accepted, as she usually did, even though there was little time to prepare it. Corita entrusted

the project to her students and chose Mickey Myers and Paula McGowan to head two teams to create the project and manage the work. (It became the main class work of the term and the final exam.) The exhibit was called "Peace on Earth" and was constructed from seven hundred and twenty-five brown boxes; it was one hundred and thirty-three feet long and six feet deep. Each student was assigned to find quotes from five men—Dag Hammarskjold, Nehru, Pope John XXIII, John F. Kennedy, Adlai Stevenson—that showed their efforts at peacemaking. The quotes were then integrated into the exhibit.

Myers and McGowan went to New York to assemble the exhibit in the storefront-like windows. It closed after a few days, as Myers recalls, "for two reasons that had nothing to do with each other: (1) a project that had to utilize the computers in the showroom [the Gemini space mission] and (2) a failure on the part of a few of the students to observe all the terms of the contract that involved quotations from other than the agreed upon writers."[11] Corita was in Washington, DC, at the time and told the two students to do what they thought best. When the layouts were corrected, and the project completed, the windows opened again. IBM later received complaints about the display because it wasn't like IBM's usual Christmas fare, and there was some fear expressed that the quotes would foster sentiments against the build-up of the Vietnam War. This IBM exhibit was an affirmation of Corita's art and an acknowledgment of her influence through the work of her students.

The question of taking commissions from corporations is always dicey for artists who wish to maintain their creative autonomy. While censorship was always a possibility, Corita was not alone among artists in taking commissions from corporations especially in the last fifteen years of her

life. She managed to convey social awareness and social justice convictions just the same, and the corporations accepted the layered meaning of her art.

In 1966 David Lewis of Group W (Westinghouse) asked Corita to do a series of print advertisements for the broadcasting company, and she continued this for several years. These ran as full-page ads in national publications such as *Newsweek* and *Time*. Lewis chose a quote, and Corita could decline if she wished, but never did. At one point the president of the company collected the ads and had them printed in a book titled *The Corita Collection: An Expression of Broadcasting Philosophy*. Although out of print, it is described as a book on the social aspects of radio and television broadcasting.

The next year she and her students created "Survival with Style," again using cardboard boxes—1,500 of them—arranged in various architectural styles that created a maze for people to walk through. The Franciscans allowed the students to use their television studio for several weeks to create the piece. Though ultimately a disposable exhibit, it was shown at the World Council of Churches in Uppsala, Sweden, and the International Congress on Religion Architecture and the Visual Arts in New York. The walls were made from boxes that were painted in bright colors and included a collage style of slogans and sayings expressed through calligraphy alongside newspaper and magazine clippings. Corita was planning a sabbatical so did not go to Uppsala, but chose a student, Donna Villicich, to travel there and oversee the setup in a museum in an old castle. Corita only saw photos and a film of it and was quite pleased. The American folk singer Pete Seeger (he cowrote "Where Have All the Flowers Gone") was there and appeared in the film, singing while people danced in and out of the maze.

Unfortunately the film does not seem to be in circulation and is not listed in the online archive of the World Council of Churches.

After Corita was named head of the art department at Immaculate Heart College, a 1966 catalog described the well-rounded courses that were offered during the regular day sessions and extended day sessions:

> Sister Corita guides off-campus commissioned projects such as the I.B.M. Christmas Exhibit, N.Y.C., 1965 and instructs students in lettering and display, art structure, art education.
>
> Through art history, Dr. Laporte puts students in touch with the traditions of the past and the trends of the present, providing the historical background vital to an under-standing and appreciation of the arts of our time.
>
> Under Detta Lange's direction students explore their interests and develop their skills in sculpture, mosaics, batik, metal work, ceramics, serigraphy.[12]
>
> Sister Mary Lenore, through a study of the history and aesthetics of film, and through assigned productions in 8mm, engages students in a serious look at film as art.[13]

Following a mention of the collection of latest art books and periodicals, the catalog listed Friday field trips for students to galleries and museums. In 1967 a six-week-session in New York was offered to art majors under the direction of the combined arts faculty.

Corita also started the "Great Men" program at Immaculate Heart that lasted two or three years and admitted years later that the program would not be called that today. Some of the men were film director Joseph Von Sternberg, music critic Peter Yates, designer Charles Eames, architect and designer Buckminster Fuller, and composer Virgil Thomson.

Corita said, "I just wrote to them and said, 'We have this program of great men; we would like you to be one of our great men and come.' We asked them not to prepare a talk but just to come and tell whatever they wanted to tell about their own life, how they had gotten to where they were, and then to answer questions from the students."[14]

Corita recalls that those "were marvelous, marvelous nights" with just students from the art department (though each department could send two students).

Corita's art began with religious images influenced by medieval and renaissance styles. She considered it "religious" art. When she began to create art using the ordinary things in the neighborhood and in the culture, and combining them with words, she realized that any art that was good had a religious quality to it.

After visiting the art department at Immaculate Heart College in 1966, journalist and Stanford professor Michael Novak (1933–2017) wrote in *The Saturday Evening Post*:

> Upon the walls of the rooms of many new sisters are serigraphs by Sister Mary Corita Kent, the artist of the renewal, whose colorful work pleased thousands at the Vatican Pavilion of the World's Fair. One of her prints reads: 'To understand is to stand under, which is to look up to, which is a good way to understand.' Reality, risk, trust, joy, love, these are the themes through which Sister Corita speaks of the sources of genuine community. Her own convent, Immaculate Heart College in Los Angeles, lives by the spirit of Sister Corita's prints. When the Immaculate Heart sisters speak of our community they do not mean only the sisters, but all the people with whom they come in contact—students, lay faculty, workmen, visitors. It would be difficult to find a more thoroughly free and joyful household in the United States.[15]

Although a larger space was rented across the street from the art department (it was possible to watch Corita working through the windows), Corita's prints were in such demand that it was not possible for her to keep up as she was also accepting freelance work for book covers, magazine art, programs, and such. In 1967 she discovered the silk-screen printing work of Harry Hambly up north in Santa Clara when he printed the cover that Corita had designed for a hospital's annual report. Corita began sending him designs and thus began a working relationship that lasted for years. They worked via mail (not even meeting for two years) and Hambly seemed to grasp implicitly Corita's vision and what she wanted. She thought his work was perfect.

Corita's sister Mary Catherine Downey worked in the art department from the early days. She and Corita were very close. Even Mary Catherine's husband, Frank, who admitted he never really "got" Corita's art, helped out by mailing copies of Corita's posters to galleries. He didn't like working with Sr. Magdalen Mary very much and called her "gruff." Mary Catherine and their brother Mark were always supportive of Corita's life and work. Her other two brothers were more traditional as was Sr. Ruth who was openly disapproving of Corita. As for their mother, every year Corita would take copies of her new pieces for her mother, Edith, to see. The last time, probably in 1964 not long before she died, she asked Corita, "Don't you think you've gone too far this time?" But Corita laughed and asked her what her favorite pieces were. Her mother chose two: an image of a heart, *the heart of the city* (based on a poem by Miguel de Unamuno), and *wonderbread* with the big colorful circles.

When Mary Catherine and Frank found gallery space on Vineland Avenue near their home, they began to ship prints from there. Corita kept the prices low so that anyone who

wanted to buy one could do so; there was never a one of a kind or numbered prints.

Sister Ruth remembers that she was not very close to Corita at that time: "We respected each other's opinions, but we were on opposite sides. I worked at the top of the hill at the library (1952–61). Corita was on the lower campus. . . . [Cardinal McIntyre] wasn't fond of Corita. He may have seen her as representing the faction of change."[16]

Cardinal McIntyre appointed Sr. Ruth as the librarian at the archdiocesan St. John's Seminary in Camarillo, California, in 1961, a post she held until her retirement in 1990.

The community's chapter of renewal called for by Vatican II was held the summer of 1967, and in August, *Harper's Bazaar* honored Corita as one of their hundred women of accomplishment for their centenary moments. As one of the chapter delegates from the Hollywood community, Corita participated fully in the chapter, continually asking people to explain what they meant, to the point that some became exasperated. But that was Corita. As in all aspects of her life, she was friendly, intelligent, focused, curious, and intuitive, and she asked questions.

CHAPTER FOUR

Heart of Hollywood

"When this plane lands you still won't know where you're going."

—*Footnotes and Headlines:
A Play-Pray Book*, 1967

Immaculate Heart College was chartered in 1916 just two years before Corita's birth. Though founded as an educational institution for women, it became coed before closing in 1980. According to alumna Joan Doyle, many students were on track to get their California elementary teaching credential, even though the college did not have an education major. This meant that anyone seeking a teaching credential had to have both an academic major and minor. Doyle recalls that the reason for this was because the college believed that teachers needed to know how to teach, yes, but what to teach as well. All of this meant additional courses in education and summer school because California required elementary teachers to take either a "Music for Teachers" or "Art for Teachers" class. Corita taught the art class each summer between 1951 and 1967. Among many memorable moments Doyle recalls Corita's

singular dedication to help us reach beyond our self-imposed limits so that our creativity could blossom in new and unexpected ways. That six-week class was jam-packed with a LOT of work. The assignments were often in multiples: 200 pen and black ink line drawings of items in the extensive folk art collection in the art department. These included music boxes, puppets, masks, artifacts, a hollowed-out log with a tree branch as a drum stick—from Africa—by which we were often summoned back to class after a break. A list of 100 things to do with our students on a rainy day was another assignment. As I recall, the reason behind doing things in multiples was to push us beyond our cramped limits. If we didn't do that list of 100, we might never have thought of the best idea, which might have been #99.[1]

Doyle, who taught elementary and junior high after college and is now a nationally certified catechetical leader, remembers how Corita taught her students to look at the world and people in new ways. Often Corita accompanied her art students to a local car wash, the Market Basket supermarket, or a tire store. Each student was given a small paper viewfinder, like the frame in a camera lens or a photographic slide mount, through which to look at items or signs and then draw what they had seen. The Corita Art Center continues to give away these small paper frames to remind people to look at the world in many different ways.

Doyle explains that Corita assigned multiples all the time: look at this object then for homework make one hundred line drawings of it. How did Corita grade students at the end of the course? She would have them grade themselves and then justify the grade. She seldom changed the grade unless it was too low. The line in the sand for her was that the students were to attend each class session because so

much learning took place there. What she could not abide and made her "furious" was if they missed the very first class because, as she said, that was the orientation class and the only one she ever taught.

If there was one thing Corita tried always to avoid in her classes it was boredom, because she had suffered through so many boring teachers in her life. She prepared thoroughly and tried to make classes stimulating and engaging. She knew herself to be naturally intuitive, and ideas for learning experiences would just come to her. There was also much mutuality of learning in her classes; students and teachers learned from one another.

She taught adults in evening classes in the college's extension program that welcomed men and women as part-time students or to take classes for continuing education. It was something she enjoyed very much. As they worked on the various projects, especially in the sixties, she tried to be aware that people in her classes were of diverse beliefs and was careful not to proselytize. On the other hand, because of the issues of the day or in noticing things around them, it was difficult to separate the religious from the secular. How these were connected became the theme of all of her art. She believed that if the art was good, it would implicitly have religious qualities that united people.

Corita was an avid photographer as well, always with the camera in her hands. She took thousands of slides that she would use for her lectures; she took slide photos for Dr. Paul Laporte's lectures too.

Corita taught her students how to make collages from various sources such as magazines and newspapers, Doyle said, "but only with photos or pieces of paper with straight edges, rectangles or squares—never curves. This was so the pieces would fit neatly together and not be random and

sloppy." How the juxtaposed pieces related and connected into a whole was Corita's focus.

Corita never drew anything for students to copy or asked students to copy the art of others. Doyle said the only exception was "our learning how to do Chancery Cursive (italic) print. In this case she showed us how to hold the pen, printed a few sample letters on a chalkboard or easel pad (can't remember which), and then gave us each a sheet with a commercially printed alphabet on it and let us go to town, practicing words."

David Mekelberg (1939–2010) was one of the first men admitted to Immaculate Heart College to pursue a degree in art. He was already an accomplished calligrapher and would go on to design more than seven hundred cards for the Benedictine's Printery House in Conception, Missouri. He recalled in a 1983 interview in *Friends of Calligraphy* magazine that the motto of the art department was the Balinese saying, "We have no art, we do everything as well as we can."[2] He said, "The work there was very integrated, it was very intense, and that was in every class." Mekelberg said that the smartest thing he ever did was to decide to apply and go to Immaculate Heart College. As to what Corita was like, Mekelberg recalled:

> The first assignment was in Lettering and Layout . . . to carve, without instructions, five complete alphabet sets in one week. We had to carve a sans serif alphabet, a roman face, a decorative face, and then we had to take ordinary cursive script and turn it into a stamp set where all the connective strokes would connect, which I still think is outrageous. The follow-up in the first week was to create a piece with each stamp set. She used to call homework your ticket. If you did the homework, you had the ticket to get back into class.

Miv Schaaf, who wrote the "Things" column in the Los Angeles Times "View" section from 1972–87, was one of Corita's students. She sent Corita a copy of her February 10, 1985, column about her former teacher with a note in the margin, saying, "I remember when you gave us an assignment of listing 500 things one could do with a brick!"[3]

With her students Corita created a list of ten rules for students and teachers, followed by hints. She borrowed one of the rules from John Cage (1912–92), the musician and artist with a spirit akin to Corita's:

> Rule One: Find a place you trust, and then try trusting it for awhile.
>
> Rule Two: General duties of a student—pull everything out of your teacher; pull everything out of your fellow students.
>
> Rule Three: General duties of a teacher—pull everything out of your students.
>
> Rule Four: Consider everything an experiment.
>
> Rule Five: Be self-disciplined—this means finding someone wise or smart and choosing to follow them. To be disciplined is to follow in a good way. To be self-disciplined is to follow in a better way.
>
> Rule Six: Nothing is a mistake. There's no win and no fail, there's only make.
>
> Rule Seven: The only rule is work. If you work it will lead to something. It's the people who do all of the work all of the time who eventually catch on to things.
>
> Rule Eight: Don't try to create and analyze at the same time. They're different processes.
>
> Rule Nine: Be happy whenever you can manage it. Enjoy yourself. It's lighter than you think.
>
> Rule Ten: "We're breaking all the rules. Even our own rules. And how do we do that? By leaving plenty of room for X quantities" (John Cage).

Hints: Always be around. Come or go to everything. Always go to classes. Read anything you can get your hands on. Look at movies carefully, often. Save everything—it might come in handy later.
There should be new rules next week.[4]

Joan Doyle remembers Rule Three in particular about the teacher pulling everything out of her students! Corita was very good at that. Doyle says that Corita was

demanding and loving and encouraging. *Demanding*: when she gave an assignment, she required that it be completed and on time (no exceptions, no excuses). *Loving*: we also had to work mindfully in class. However, one day in the class we had after lunch we all noticed that a *very* elderly nun, who was a student in the class, had fallen asleep, head down on her art table. Corita asked us to try to do our work quietly so as not to wake her up. She said she needed the sleep. I believe they lived in community together there at the Immaculate Heart convent and she knew the sister well. *Encouraging*: she would write comments on our assignments before she gave them back to us. Once, a comment on my collection of line drawings said, "Another wrong major." I was an English major, not an art major. I have treasured this comment ever since.[5]

In 1964 the art department added film studies headed by Sister Mary Lenore Dowling. Besides photography Corita had always used film in her art teaching, especially the films of modern artists such as architects and designers Charles Eames and his wife Ray. With the permission of their superior, Corita, Sr. M. Lenore, Sr. M. Fleurette (the drama instructor), and other sisters would sometimes go to see a film in a movie theater but would enter through a side door "surreptitiously" after the film had begun and leave before

it was over. They watched Fellini and the neorealism Italian and new wave French films. They really liked foreign films. Immaculate Heart College students attended special screenings with faculty at local theaters as well.[6]

Corita had some sage advice about film viewing: "Don't blink" or you could miss something. Back then (and sometimes today) films were made on photographic film stock and ran twenty-four frames per second (frame rate standards for digital film vary today and are usually expressed as progressive scan rates). Each frame was like a still photograph with something significant. She fretted that people so often went for the story, yes, but didn't stop to consider the images and what the elements were in the frame, how they were placed, what they meant, and how they were an integral part of the film experience.

Three films are available that illustrate Corita's life and teaching; they are worth watching to get to know her better—her demeanor, the sound and cadence of her voice, her intensity and intelligence, her humor. Then there is her philosophy of art and unique classroom pedagogy. Although Corita would become anxious before giving a lecture, often contributing to sleep loss, she seems at once proper and at home in front of a group. Baylis Glascock captured Corita leading a "happening" in Boston. She is methodical and measured, quick to catch her own unintended jokes, and connected to her audience. That she could lead a happening experience in a theater where people are confined to rows is a tribute to her abilities as a teacher for whom possibility is a constant.

Alleluia: The Life and Art of Corita Kent: the '60s (1967) is a relatively short film produced and directed by Thomas Conrad. It shows Corita teaching and working in her studio and making serigraphs in the summer in her full habit, all

the while narrating what she believes about art, art education, and teaching teachers to teach art. Toward the end she says that her special area of art is illumination, "taking a word and joining it to an exciting image, like the monks of old. A word throws light on form and a form throws light on a word. It's a very narrow area of art, but it delights me."

Primary Colors: The Story of Corita (1991) was produced and directed by Jeffrey Hayden and narrated by his wife, Eva Marie Saint. The film is about Corita's life and art, has interviews with family, friends, and colleagues, and shows some of her most significant work. This film was shown as part of the traveling art exhibition of Corita's life and work, "Someday Is Now: The Art of Corita Kent," in Pasadena, California, in 2015 and in other locations, including Andy Warhol's hometown of Pittsburgh, Pennsylvania.

Ten Rules for Students and Teachers: Corita on Teaching and Celebration (c. 2007) is a compilation of short films that includes two by Corita's friend the filmmaker and film editor Baylis Glascock: *We Have No Art* and *Mary's Day 1964*. Also included are several brief interviews, one with Sam Eisenstein, a longtime friend, in 2000.

As an educator and an artist, Corita believed firmly that one cannot analyze and create at the same time; they are two different functions. This is another reason why she assigned "jobs" as she called them, or tasks, in great multiples—much to the dismay of many students. To draw something over and over and over again, by the twentieth time one stops analyzing and moves beyond self-imposed limits to be free to create. That's when people do their best work, she said, and when people who do not think they are artistic realize they, too, are artists. She believed everyone was an artist.

The happenings she initiated in the sixties and into the seventies were really celebrations of people coming together

and getting to know one another. They also served to free people to laugh and talk with a stranger whom they otherwise might not greet or get to know. Initially Corita may have become familiar with the idea of a "happening" because John Cage, who lectured at Immaculate Heart on occasion, had a kind of musical happening going on as early as 1952. One of his students, Allan Kaprow, used the term in 1957 to describe an art event. Happenings became celebrations of art, music, and life.

Corita was quite good at giving very precise instructions (as the films demonstrate) and even after she left teaching she would bring the happenings or celebrations to universities and corporations. For example, she had people stand with even-numbered rows looking forward and odd-numbered rows turning and looking at the evens to greet their new friends. Everyone would get a bag with a pin attached. In the bag was a piece of colored tissue paper that people were to tear a hole in and pull over their heads. Some had balloons to blow up and let go, and some had poppers to pull that released scrunched streams of paper. As the balloons came down people were to pop them with pins and then take the slip of paper in the bag with a quote from a poet (E. E. Cummings was a favorite) and whisper the poem into the ear of a new friend. Finally they were to pick up all the debris and put it back in their bags to take with them to remember the happening.

As an ice breaker, the celebration "happening" was a winner, but even at the end of an event, as at a meeting of theologians at Princeton, it involved everyone and got everyone talking together.

At the end of a class, sometimes she and the students would analyze their work. To Corita bad art was when the elements didn't fit together well. But she was ready to admit

her own prejudices about what constituted bad or ugly and look again at what she instinctively did not like only to find that she did like it. She had to set aside her own artistic rules for the rules of another artist.

Former student Joan Doyle said that what she learned from Corita is still relevant:

> As a teacher I try to create circumstances for learners to think new thoughts and look for new ideas. I did it with my junior high students in Catholic school and I do it now with adults. I also try to apply a certain sense of artistry to the materials I use as teaching aids, whether electronic presentations or handouts. I think about the way color, fonts, and design go together. Corita helped me "frame" the way I present theology or catechetical methods, or learning styles; to frame not only the look of it all, but to frame the essence of the content as well.
>
> Corita reminds us that there is infinite beauty in the world around us and we can find it in unexpected places and in unexpected ways. We do not have to be limited by concentrating solely on the expected or the ordinary or the obvious. We need to push beyond and discover the new truths we might never discover without risking a journey of discovery.

CHAPTER FIVE

Heavy Heart

"Before you take sides read all the sides."
—*Footnotes and Headlines:*
A Play-Pray Book, 1967

Corita was reaching the height of her artistic productivity as a sister, artist, and instructor at the college in the early sixties. But as the Second Vatican Council neared its conclusion in 1965, Corita was entering a time of discernment at about the same time as Cardinal McIntyre began testing her community with new complaints about the sisters, adding fuel to old ones.

In order to understand Corita's place in the events that followed the council and how they affected her journey in relation to the IHM sisters, it is useful to review the thorny relationship between the cardinal and the sisters over the years. Unfortunately Corita was a frequent target for the cardinal's ire. Although Corita took a leave of absence and sought a dispensation from her vows in 1968, her participation in the life of the community before, during, and after that year are forever intertwined.

The Immaculate Heart of Mary sisters were following Vatican II closely from 1962 to 1965. They were prepared for what the council would say from as far back as the early fifties by being part of the Sister Formation Conference, founded in 1954 by a Monroe, Michigan, Immaculate Heart sister Mary Emil Penet (1916–2001) to advance the spiritual, psychological, educational, and professional lives of sisters. One of the inspirations for the sister formation movement, as it came to be known, came from the words of Pope Pius XII at the First International Congress of Mothers General in Rome in September 1952:[1] "It is Our fervent wish that all [your schools] endeavor to become excellent. This presupposes that your teaching Sisters are masters of the subjects they expound. See to it, therefore, that they are well trained and that their education corresponds in quality and academic degrees to that demanded by the State. Be generous in giving them all they need."

The education and preparation of most religious sisters in the United States up until Vatican II was on the "20-year plan" to receive a bachelor of arts degree—not intentionally but because that was the only way they could teach and study at the same time. The Sisters of the Immaculate Heart of Mary in Los Angeles had been concerned about the preparation of their sisters for decades. The demand to staff schools was always great, whether from the church, parishes, or the congregation itself. This demand led to many sisters, as in Corita's case, going into classrooms right out of high school and later studying at night to get their degrees after they made their religious profession. When Cardinal McIntyre was installed as archbishop of Los Angeles in March 1948, the postwar housing boom was in full swing, and he immediately began to plan for more parishes and schools to meet the needs of his growing flock.

Who Was Cardinal McIntyre?

Cardinal McIntyre, known as serious and timid as a teen, was born in New York City in 1886; due to family circumstances he had a limited education. He and his brother attended public schools because the family could not afford Catholic school, which may have been an impetus to making Catholic education more available to families when he became archbishop of Los Angeles. He began working as a runner for the New York Curb Exchange (later the American Stock Exchange) at the age of thirteen.[2] His penchant for numbers got him his first salaried job to watch the crowd and then report fluctuations in prices as trading went on at the corner of Broad Street and Exchange Place. He then became a switchboard operator at a financial company and worked his way up, specializing in equities and property values. He progressed to the level of stockbroker, and the firm offered him a partnership when he was twenty-nine. As his father had recently died, James was free to follow his desire to be a priest. So he turned down the partnership and entered St. Joseph's Seminary in Dunwoodie, Yonkers, New York.

First, he spent a year at the minor seminary (Cathedral College then located in Manhattan) to make up for his deficiencies in the classics and to study Latin. Then he entered St. Joseph's, the major seminary, to assume a highly regulated life, much like the military (the director of the seminary had been a Navy chaplain). He is remembered as someone who followed the rules. He completed the requirements in a year and graduated in 1916, but his education was mostly self-realized through experience.

At St. Joseph's he was generally a good student, "though he struggled considerably with the Latin texts then used for dogmatic and moral theology."[3] He was remembered as

having "an aversion to breaking the rule."[4] The seminarians would also have taken to heart the oath against modernism prescribed by Pope St. Pius X in 1910, an oath they would take immediately as new priests.[5] The seminary rector demanded a rigorous academic environment, but it is not clear if this referred to the schedule or the subjects studied. Dunwoodie historian Fr. Thomas A. Shelley noted in 1993 that McIntyre and his classmates were "shortchanged intellectually and spiritually," although it was an opinion not shared by everyone who was in McIntyre's class.[6]

McInyre finished the six-year seminary course in five years and was ordained in 1921 at the age of thirty-five. He was ordained an auxiliary bishop of New York in 1941 and named coadjutor archbishop in 1946, meaning he would probably succeed Cardinal Francis Joseph Spellman. With McIntyre's business and financial background and expertise, Spellman relied heavily on him when it came to decisions in the Archdiocese of New York. McIntyre did not succeed Spellman in New York; instead he was appointed archbishop of Los Angeles in February 1948 and named a cardinal in 1953.

This was an extraordinary journey for a man without a high school diploma.

Cardinal McIntyre in Los Angeles

The Immaculate Heart sisters had a great champion in Archbishop Cantwell whom McIntyre succeeded. Archbishop Cantwell initiated the congregation's process to become an American foundation of papal right in 1924, and he and the community enjoyed a mutual, trusting relationship. Such was not to be, however, with Cardinal McIntyre who soon took what we would call today a micromanaging

approach in dealing with the sisters. After all, their mother-
house was in the middle of Los Angeles, the sisters taught
in many of the schools, and though small, their college for
women was becoming a high-profile Catholic educational
institution of higher learning. McIntyre took a keen interest
in textbooks, instructors, and speakers at Immaculate Heart
College and began to challenge the college's academic free-
dom within a few years of his arrival.

For example, though he first approved a proposal for a
social research center at the college in November 1957,
he rescinded his decision four days later, writing through
the superintendent of schools that the cardinal "does not
feel, however, that Mental Health, Marriage, or Mexican-
American Youth problems should be pin-pointed at the
present time. In view of the fact that your students will
be undergraduates, he would prefer that no immature
assessments be made."[7]

Not long after, the library was told to avoid the works of
Jesuit existential phenomenologist Teilhard de Chardin, and
students were not to be allowed to have access to his writ-
ings or studies.[8] When Mother M. Humiliata, PhD, a noted
scholar on the French Catholic author François Mauriac,
was invited by the University of Judaism in Los Angeles to
speak about Mauriac, she asked permission as the cardinal
required. He replied that a lay professor go in her place. An
exchange of letters followed but finally the president of the
college, Sister Mary William, had to write to attest to
M. Humiliata's expertise, saying, "I will of course, abide by
your recommendation, if this continues to be your wish,
although it is embarrassing both to us and to the University
of Judaism."[9] M. Humiliata was allowed to give the talk.

Then there was the cardinal's rather damning judgment
of Corita's art in the fifties and the Mary's Day celebrations

in the sixties. After the food-themed Mary's Day in 1964, Sam Eisenstein, now an English professor at Los Angeles City College, wrote to Corita about his experience that day: "If a canned food company feels justified in saying their tomatoes are the juiciest, it is not desecration to say, 'Mother Mary is the juiciest tomato of them all.' "[10] This inspired Corita to make a serigraph of Eisenstein's word *tomato* that she produced in 1967. Today no one would be negatively impressed by Eisenstein's statement. The etymology of the word *tomato* is from the Nahuatl (Aztecan), meaning "the swelling fruit." But in the 1920s it seems to have had a seductive meaning when used colloquially. Corita, knowing the power of words, wanted to reclaim the meaning and given the relationship between Mary's Day and its theme of food and peace, she produced the serigraph.

Cardinal McIntyre was never able to grasp the artist's connection between the religious and the ordinary or the incarnational theology underpinning Corita's art. To the cardinal, Corita's art was sacrilegious. Although he did not react immediately to the 1964 Mary's Day, he would two years later in 1966 and to the *tomato* print in 1967.

The contrast between the authoritarian cardinal and the dynamism of the sisters as women consecrated to Christ for Catholic education was becoming clearer. This reality was reinforced in an Associated Press obituary of Cardinal McIntyre that appeared July 17, 1979, in the *New York Times*:

> Cardinal McIntyre was one of the most prominent, dynamic and controversial of the Roman Catholic Church's prelates in the United States. He was known as a leading conservative in what some Catholic analysts called the church's internal "cold war" over modernization of secular policies and practices. . . .

In the new image of the Catholic Church as propagated by Pope John and continued by Pope Paul, Cardinal McIntyre represented a different church attitude. The Cardinal was in the tradition of the old Irish Catholic priest—stubborn, paternalistic, authoritative, frugal and puritanical on moral behavior. But he left monuments in his archdiocese in brick and mortar, solidly financed."[11]

The obituary also notes that in 1964 John Cogley, religion editor of the *New York Times*, wrote of McIntyre: "He has been described by more than one Vatican observer as the most reactionary prelate in the church, bar none not even those of the Curia."

The Second Vatican Council

Cardinal McIntyre participated in the Second Vatican Council, but he became ill at the beginning of the third session and left Rome before the conclusion of the fourth and final session. According to his biographer and admirer, Msgr. Francis J. Weber, the cardinal voiced his objections forcibly when he had them but actually agreed on 95 percent of matters that came to a vote. If he was outvoted, he graciously conceded. At the same time he was especially against both permitting the vernacular to be used in the liturgy and, as we shall see, renewal in the religious life of sisters.[12]

Meanwhile the Immaculate Heart sisters were reading and studying each of the sixteen documents as they were published between 1963 and 1965. They took to heart the council's call to renewal with enthusiasm and had studied the documents leading up to the council as well. They had begun to update their vision, moving from concern over the schedule to the meaning of their charism at the general chapter in 1963. When *Perfectae Caritatis*, the decree on the

Adaptation and Renewal of Religious Life, was issued on October 28, 1965, and then implemented by *Ecclesiae Sanctae* in 1966, the sisters paid close attention.[13] This latter document contained directives on how to implement four of the decrees of the Vatican Council, including *Perfectae Caritatis*. The sisters carefully planned an authentic *aggiornamento* (renewal) for the chapter of renewal to rewrite their constitutions (rule) that would return to and express the charism of their founder and to respond to the signs of the times. The date for the chapter of renewal was set for the summer of 1967 and would conclude in a second session in 1969. As a congregation of papal right, the Vatican, not the ordinary or local bishop of a diocese, would approve the new, final constitutions to be written in 1975 after some years of experimentation allowed by church documents.

The regular every-six-year general chapter held in 1963 at the novitiate in Montecito showed that the congregation had made significant progress from the 1957 chapter's concern over "grand silence while driving at night, the dilemma of wrist watches versus pocket watches, the number of buttons on one's sleeve and the very fabric of the inner sleeve and the vexing problem of allowing traveling sisters to eat at drive-ins [to] larger issues of theology, appropriate changes in the liturgy, and the need for professional growth."[14]

Not all the sisters were happy with the idea of this renewal and change and some made complaints to the cardinal's office.

Because of Corita's celebrity and profile as an artist (see chapter seven) the cardinal would have been aware of everything she did, especially if the media covered it or members of her community reported it to him.

The directions away from the conventual lifestyle of cloistered nuns in which the chapter of renewal took the sisters—

including inviting retreat directors like Fr. Noel Mailloux, OP, and Adrian Van Kaam, CSSp, along with a team of psychologists from Duquesne University—worried the chancery office and added to the cardinal's growing unhappiness and suspicion of the inner workings of the IHM sisters.

In response to these complaints and his suspicions, the cardinal decided in November 1965 to carry out an investigation of the Immaculate Heart of Mary sisters, something he did for no other congregation in the archdiocese. He sent a team of priests to ask each sister to answer questions that showed not only the prevailing patriarchal attitude of the cardinal and his associates but a profound lack of trust for, and understanding of, the life of women and mission of the Sisters of the Immaculate Heart of Mary: "Do you think that the Sisters' sex life is affected by reading novels? Don't you think it will take too much time to fix your hair if you were to update your habit? Do you want to look like a little girl? Do you want to look like a floozy on Hollywood Boulevard? What did you think of a course on James Joyce taught a couple of years ago at your college? Do you know how pornographic *Ulysses* is? Do you know why your community is being investigated?"[15]

Questions asked at the novitiate in Montecito centered on liturgy and obedience. In an incredible twist of logic the postulants and novices were asked to evaluate the effectiveness of the formation team.

The cardinal concluded at the end of the investigation that the IHM sisters were not living an authentic religious life as defined by the Archdiocese of Los Angeles: the sisters were not observing the silence, were substituting a Scripture service for the weekly holy hour, and were praying the rosary privately rather than in common. Although the changes the sisters had instituted were a result of the 1963 general

chapter and not subject to the cardinal's approval but to the Vatican's, he gave the sisters sixty days to decide if they would live the traditional religious life as he defined it.

Though an uneasy truce existed between the cardinal and the IHMs, the sisters appealed to the Vatican from 1965 until the 1967 chapter of renewal. The Sacred Congregation for Religious assured the cardinal of the sisters' fidelity, but it had little effect. The cardinal countered by ordering another investigation regarding religious observance, and this time wanted to know if sound doctrine and good morals had suffered in any way in the congregation.

It became evident by the cardinal's response that he had missed the point of the renewal called for by Vatican II for women religious. He was more concerned about the conventual schedule (as lived by cloistered nuns) and the style of life indicated by canon law of 1917 (that made up at least 80 percent of any apostolic community's constitutions or rule at the time) than a return to the spirit of the founder and an updating of lifestyle, mission, spirituality, education, and preparation as well as the habit that the Vatican council called for. The reason experimentation with the habit and lifestyle were permitted was so that religious life would be renewed in fidelity to Christ and the church, responsive to the signs of the times, and relevant, able to serve the people of God without being tied to the demands of a conventual schedule. This did not mean that women religious, including the IHM sisters, did not make mistakes of judgment and action during this experimentation process. But instead of offering guidance or opening a dialogue with the Immaculate Heart sisters, the cardinal and officials at the chancery office exerted dominance and control in ways that were frankly oppressive rather than pastoral. Despite it all, the sisters continued to carry out their mission and to prepare for the chapter of renewal.

The changes that would be made in canon law in 1983 regarding apostolic religious life reflect Vatican II's invitation and promise, but in the sixties all Cardinal McIntyre had to go on were the 1917 canons. He did not seem very aware of, or accepting of, Vatican II's teaching on religious life. For the cardinal, it wasn't just about lifestyle and the habit, it was about the professional standards for teachers and education of the sisters and what this would mean in practical terms for the schools of the archdiocese. If the sisters returned to college to acquire or complete their degrees or obtain teaching credentials, they would not be teaching in schools. He would have to look for new teachers, religious and lay, for the many schools of the archdiocese; this was not acceptable. He took the sisters' decrees as an ultimatum.

A sister from another teaching congregation with papal approval was stationed in Los Angeles during these years of conflict between the cardinal and the Immaculate Heart sisters. She remembers a conversation in her community when the question was raised about why the cardinal was treating the IHM sisters so harshly when he was not acting like that with other communities whose members were also engaged in renewal and experimentation—such as their very own community.

Several Jesuits wrote a letter in support of the Immaculate Heart sisters. The noted theologian and author Fr. Thomas Rausch, SJ, was in residence at what is now Loyola Marymount University and went with a group of Jesuits to meet with Cardinal McIntyre in support of the sisters. It was to no avail.

Tensions continued. The IHM leadership team went to the Vatican, a visit that resulted in the Vatican appointing a commission of three US bishops and a priest to investigate the life and mission of the IHM sisters in 1968. The

commission issued four points that the sisters must adhere to in a letter sent to all American religious communities *in advance* of the May 1968 Vatican visitation to the IHM sisters. The decision was cast in favor of Cardinal McIntyre even before the commission arrived in Los Angeles. These four points were: members must adopt a uniform habit; all sisters must at least attend Mass together; the sisters must maintain their constitutional directive to engage in education; the sisters, especially those of pontifical right, must observe due collaboration with the local ordinaries.

It is astounding even today that the Sacred Congregation for Religious at the Vatican did not support the Sisters of the Immaculate Heart of Mary for two reasons. One, the congregation was of papal right and deserved the support and respect of the sacred congregation, and two, the very documents issued by the Second Vatican Council on religious life and how to implement the renewal were ignored by the very people whose charge it was to implement them.

The Chapter of Renewal

In preparation for the 1967 chapter of renewal, the sisters created commissions that produced five documents in key areas to be taken up by the chapter: apostolic works, the person in the community, apostolic spirituality, authority and government, and preparation for life in community. These would be discussed at the chapter of renewal and finalized. These decrees would be published as documents and would guide the lives of the sisters, acting as interim constitutions or rule, until the second session of the chapter scheduled for 1969. The decrees also contained a timeline for implementation.

One of the most significant decisions made in the decrees was that by June 1968 contracts were to be made between

the community and parish schools about payment, hours, housing, and health care, and the sisters were to be included in the negotiations. The sisters would be permitted to continue to wear the present habit, wear a modified habit with or without a veil, or to wear regular clothes. The sisters also said they would assign to schools only sisters who were prepared (meaning fewer sisters available to teach for the time being) and would withdraw from schools that would not make agreements with the sisters. Cardinal McIntyre and the priests whose schools would be affected by fewer teaching sisters who were paid very little, took this as a threat and an ultimatum. And the cardinal could not abide the thought of sisters teaching in his schools without a veil or in secular dress.

The Vatican commission called for another meeting with the IHM board of directors (in the past, general council) on May 31, 1969, as the IHM sisters had not made a clear statement about their intentions regarding the options offered them: to accept the four points, disband, or become a secular institute. The sisters held out for a chance to dialogue with the cardinal but that did not happen.

The meeting was called on short notice so only the sisters stationed in California could attend. Corita was invited to be present. Even though she had been released from her vows six months before, she had participated in the chapter of renewal and contributed much to the work it accomplished. There was not much of a response to the proposals by the commission, but at one point Corita stood and asked, "What do you think Jesus would have done had he been given the choice?" To which the members of the commission gave no response.

Mother M. Humiliata (Anita M. Caspary) was the mother general in October 1967 when the cardinal reacted to the decrees and proposals of the sisters. She wrote about this

and what followed in flowing prose, great detail, and documentation in *Witness to Integrity: The Crisis of the Immaculate Heart Community of California* in 2003.[16] The long and short of this was that the cardinal's reaction called for an archdiocesan commission to arrange for the orderly withdrawal of the IHM sisters from diocesan schools, full stop. The sisters were shocked because it seemed he had not read the Vatican II documents or their own decrees that motivated their proposals, and he did not ask for a conversation or dialogue about the matter. McIntyre made his decision even before the sisters arrived in his office for a meeting. He told the members of the IHM leadership team that day: "For years now you have been disobedient to me and to my office. You've continued to have your speakers without my approval. Your sisters can be seen at all hours of the night attending, or even speaking at public meetings in public auditoriums, and on topics with non-Catholic speakers. I get calls night and day about what the Immaculate Heart sisters are doing now."[17]

One can only imagine if this dispute had happened in the era of social media. The pressure from outsiders and groups (suspicious donors, uncertain alumni, fearful Catholic special interest groups) on any bishop—or a high-profile archbishop like Cardinal McIntyre—would be immediate and intense. And as happened with the aging Cardinal McIntyre, then eighty-four-years old, it might just be easier to silence those accused of causing a problem than to deal with the validity of the complaints that were being made or enter into dialogue with the group or individual reporting. These lost opportunities are the difference between spontaneous reaction and a well-reasoned and informed response. The consequences of reaction over response for the Immaculate Heart sisters and the people they served were severe indeed.

New Beginnings

Not all the IHM sisters were in agreement over the proposals for renewal made in the decrees voted on by members of the chapter of renewal, including Sr. Ruth, Corita's older sister. The 1968 commission that made the visitation decided to resolve the rift in the congregation by dividing the Immaculate Heart sisters into two groups under different leadership. But before this could happen, per the cardinal's mandate, the congregation withdrew from the schools of the archdiocese in June 1968, the sisters careful to leave everything in order for those who would follow. The majority of the total 455 sisters were to be allowed to continue experimentation according to the five chapter decrees under Mother M. Humiliata, now called Sister Anita (the sisters were allowed to return to the use of their baptismal names) and a smaller group of 51 members would continue to follow the constitutions in effect before the 1963 chapter under the leadership of Sr. Eileen MacDonald. Both groups agreed on a division of assets and property.

The end came for the larger group of IHM sisters with finality in May 1969. Even after meetings with representatives of the archdiocese, no mutual understanding was reached over the chapter decrees or the four points from the Vatican's commission. The cardinal told the sisters who were under Sr. Anita's leadership that if they did not adhere to the four points they would not be religious any longer. Always believing that the IHM sisters were living in accord with the church as written in the Vatican II documents, Sr. Anita wrote to the sisters in December 1969 and asked for their preference: to join a more traditional community, to obtain a dispensation from vows and disassociate from any group, or to form another religious community with the four points as guidelines.

Both sides had to make a decision in accord with their consciences. Most of the 455 sisters decided to sign the forms sent to them that would dispense them from their vows—though they crossed out "freely" and added "under protest." Of this group, 155 left the community definitively and 300 went on to form the new ecumenical Immaculate Heart Community in 1970. Anita M. Caspary was elected the new community's first president. The other 51 sisters decided to remain as IHM sisters under Sr. M. Eileen MacDonald and follow the constitutions in effect in 1963—though they did modify their habit.

In January 1970, Cardinal McIntyre was asked by the Vatican to submit his letter of resignation as archbishop of Los Angeles, which he did. He was in his eighty-fifth year. The canon establishing the mandatory retirement age of seventy-five for clergy and bishops was still in the future.

Moving Forward

Some of those first members of the newly formed Immaculate Heart Community applied for teaching positions in archdiocesan schools and were hired. Others sought out different ministries. What the sisters asked for in their decrees is now common practice for all religious when they are hired by ecclesial entities such as schools, hospitals, parishes, and dioceses.

The IHM community is alive and well today as a lay Christian faith community. Several now retired members live together in an apartment house in downtown Los Angeles. There is a communal dining room and chapel where the Blessed Sacrament is reserved. Mass is celebrated for the community regularly. Some members are retired, and the elderly are well cared for; other members that include

married people and people of other Christian demoninations continue to proclaim the kingdom of God in their lives and good works.

These were the turbulent circumstances from which Corita at the age of fifty departed the congregation of the Immaculate Heart of Mary in 1968, thirty-two years after she entered.

In 1976 another division ensued within the original community, and Sr. Eileen MacDonald, Sr. M. Joanne Brummell and Sr. M. Giovanni Oliveri were invited to the Diocese of Wichita, Kansas, to start yet anew as a diocesan congregation. Young women entered the community and continue to do so. The community traces its history as IHM to both California and Spain. A small group of retired IHM sisters has continued to live in Los Angeles, garnering quite a bit of publicity due to a dispute with the archdiocese over a piece of property and its potential sale to pop star Katy Perry.

During Lent of the jubilee year 2000, following the lead of Pope John Paul II in asking forgiveness for the sins of the Catholic Church, Cardinal Roger Mahony of Los Angeles issued a public apology and included the dispute between Cardinal McIntyre and the Immaculate Heart Community. The IHM leadership wrote a letter to Cardinal Mahony to acknowledge this unprecedented apology to the community.[18]

CHAPTER SIX

New Heart

"Life is a succession of moments . . ."
—*moments* series, 1977

In 1966 Corita was named one of nine "Women of the Year" by the *Los Angeles Times,* and in 1967 she was on the cover of *Newsweek*, the photo showing her in the habit and another of her in secular clothes against the backdrop of her art. Her art was gaining notice everywhere. Much to her dismay, Corita had become willy-nilly the face of the changing nun in post-Vatican II America. This continued notoriety did not make Cardinal McIntyre happy, and some of the IHM sisters were displeased and worried as well.

Daniel Berrigan, SJ

Jesuit Fr. Dan Berrigan (1921–2016) first encountered the Sisters of the Immaculate Heart of Mary in 1959 when he was invited to speak at the college. The lecture never happened because Cardinal McIntyre forbade him to address the college even though, as Berrigan remembers it, he was

not yet "notorious." Dan Berrigan, SJ, and his brother Philip (1923–2002), a Josephite Father before later leaving and getting married, were both peace activists who carried out nonviolent protest and were arrested and even imprisoned for their beliefs and actions. The two brothers are remembered especially for beginning the plowshares movement. On September 9, 1980, the "Plowshares Eight" entered the General Electric Nuclear Missile Re-entry Division in King of Prussia, Pennsylvania, and hammered nose cones for warheads, poured blood on documents, and offered prayers for peace. They were arrested, tried, sentenced, and imprisoned.

But this was still to come when Dan Berrigan first met the sisters in 1959. They influenced each other; he was inspired by the sisters' mission and accomplishments, and through him they learned about a gospel response to the social problems of the day. Dan and Corita were kindred spirits. Though he was not allowed to speak publicly at the college, some sisters and faculty members met with him in the evening to listen and talk. As far as we know, Corita kept all the letters he wrote to her, and it's easy to see how his relationship with the community and Corita went from the formal to the informal to friendship, just by his greetings from "Dear Sister M. Corita" eventually to "Corita."[1] His admiration for Corita's art was shown in the frequent requests he made of her for illustrations for his writings and poetry, often scribbled in quasi-legible writing in the margins of printed pages or asking her for illustrations for his handwritten texts, yet unprinted. Their admiration was mutual.

Corita published her first book in 1967, *Footnotes and Headlines: A Play-Pray Book,* that the famous philosopher of popular culture Marshall McLuhan called "a new form of book . . . an ex-ray of human thought and social situations." Its incarnational and humanistic approach to wordplay

delighted many reviewers. Berrigan, always a playful poet and ever a wordsmith, wrote the foreword. It seems at times like a stream of consciousness rap poem:

> The way she lived!
> mixing hot paint pots like Miss Endor's youngest sister
> shuttling her silk screen like a
> minor fate
> she was a cornucopia with fruit fly's
> eyes, a kaleidoscope, a calliope. And FREE!
> WHAT DO YOU GET FOR FREE?
> she never asked. She was
> 2 gentle by far (near.) She did. Does.[2]

Two years before, in 1965, Dan Berrigan was invited to preach a Holy Week retreat for the sisters at Montecito. They decorated his room with Corita's art (at the end of the retreat they rolled up all the prints and presented them to him). His brother, Josephite priest Phil Berrigan, was invited to speak at Immaculate Heart High School where he spoke of faith and social activism. When someone asked him what could be done regarding the ongoing military escalation, he paused for a moment and replied, "Well, we can all go to jail."

The presence of the two priests in the archdiocese was reported back to Cardinal McIntyre by some of the sisters who were uncomfortable with their social message in the retreat and at the school. Dan was reprimanded by the chancery office for conducting "illegitimate liturgies" during the retreat, and Phil was banned from the archdiocese altogether. Afterward Dan said that talking with the sisters had been a tremendous experience, and what struck him the most was their anguish over the situation with Cardinal McIntyre.

According to Helen Kelley, the former Sr. M. William, president of Immaculate Heart College and a lifelong friend

of Corita, Berrigan and Corita were kindred souls. His activism greatly influenced Corita and the spirit of her art.

It is apparent that Corita was fond of Dan Berrigan by the way she spoke about him. In the UCLA Oral History she calls him a pixie because of his slight stature and twinkling Irish humor, and that he never came down hard on anything or anyone—unlike his brother, then-Fr. Phil Berrigan, who could be very strong when he spoke. Dan's indirect style was very appealing because it involved asking questions and humor.

It is sometimes intimated that Daniel Berrigan and Corita were more than friends; if so there is no evidence of it in the letters he sent her, that she kept until her death. He was all about advocating for peace and nonviolence, and crying out against the abuse of power. Corita admired Berrigan's activism and willingness to go to prison for his beliefs but it was not for her. She acted through her art. It will be interesting to see if Berrigan, who died in 2016, kept Corita's letters. If these exist and come to light, a look at a marvelous, enduring friendship of the spirit could emerge.

Changes

In 1964 Sr. Magdalen Mary, after more than thirty years as head of the art department at Immaculate Heart, decided to move on to work that took her to England. The more-than-fifteen-year working relationship between the two very different women, one an extrovert and the other an introvert, had unraveled.

According to Mickey Myers, Corita had become focused on "the relationship between the biblical call, social consciousness and the need to make art."[3] Corita's art reflected this consciousness or connectedness, and this did not bode

well with Sr. Magdalen Mary. Pat MacDonald, a former art student at Immaculate Heart, remembers that the older sister would storm into the office, upset. Even the students realized that there was little love lost between the two; Sr. Magdalen Mary was focused on the art department, and Corita, ever the teacher, had her gaze set on social issues and political events and movements when it came to her art. It was time for a change.

Corita was appointed to take Sr. Magdalen Mary's place as head of the art department, an assignment that added to Corita's schedule and work overload. She did finally ask Mary Anne Karia (née Mikulka) to act as her secretary. She was the daughter of Elinor Mikulka, a former student, friend, summer helper, and great fan of Corita's art. Mary Anne, who had also taken Corita's summer class, remembers that one day Corita stopped class so they could go outside and spend a whole minute gazing at a blade of grass. Mickey Myers remembers that looking at the blade of grass WAS the class and it was much longer than one minute! Afterward they came back in and discussed what they had seen and experienced. At other times Corita would project two of Charles Eames films simultaneously or show a slide show and a film side by side.

Mary Catherine, Corita's sister, was also working with her, helping with administration and details. In fact it was she and her husband, Frank, who found the space on Vineland Avenue for a gallery to exhibit and distribute Corita's work.

It should be remembered that most women religious did not take vacations before the renewal called for by Vatican II. In the early fifties Pope Pius XII asked women religious to simplify their habits, community customs, their understanding of authority, and to advance the educational preparation of teaching sisters so they would be on a par with

their secular colleagues. It is unlikely that vacations would have been considered customs; they just weren't considered. For Corita there was never a vacation unless making art was how she chose to relax, but that is doubtful. She taught for at least ten and a half months of the year, made her annual retreat, and then had the month of August to feverishly create new art. For ten years she and Sr. Magdalen Mary had used their Christmas break to travel, give lectures, and visit museums.

After ten to fifteen years in the community, IHM sisters were allowed a tertianship or short sabbatical, lasting a summer. They would take this time to reflect on their life and vocation. Although Corita and Dan Berrigan led sabbatical workshops for some sisters in Montecito in 1966, there is no indication that she ever took one. Would it have made a difference if she had? We'll never know.

One former sister recalls that whenever she walked by Corita's bedroom at night, she could always see the light under the door. Another sister says that in Corita's earliest years in the community, she slept near a stairwell door, and each time someone came and went the door clicked shut or banged. She never complained and insomnia became her constant companion. Lenore Dowling, who traveled with and worked closely with Corita from 1966–68, says Corita was always fatigued due to the insomnia. Her nights were even more restless because of anxiety if she was scheduled to speak the next day.

Corita's former student and friend Mickey Myers recalls in a letter to Julie Ault for her book *Come Alive! The Spirited Life of Corita Kent* what it was like in the cinderblock studio across from the college on Franklin Street, with large windows, the sun beating down, no air-conditioning, and how Corita was dressed in her full habit with the:

woolen scapular [the sisters changed to polyester habits around 1945 but retained the wool scapular; polyester could not have been much of an improvement on wool when it came to heat], starched coif, two layers of veil, and long indigo woolen dress, pulling a three foot long squeegee that took strength and muscle to pull evenly, especially when you were printing prints that were large and the color coverage was solid. She did all the printing herself. . . . And it smelled, of paint thinner and the awful thick, heavy smell of silkscreen paint, and the transparent base . . . the more she printed the more it smelled until the air was so thick with the fumes and the exhaust and the sweat of summer that I am told lunch time was a heavenly relief back at the convent.[4]

Some of the sisters would help her as well as friends from far away, and each one had a job to do. Myers concludes, "I think that the most important thing about this scene is that everyone who was there, wanted to be there." From the three documentary films in existence about Corita, we can see that she wore the full habit, though removing the elbow to wrist sleeves to work on silk screens, probably until the chapter of renewal in 1967 when a modified habit was permitted. She was wearing the modified habit in some 1968 footage, but before she went on sabbatical, she and many of the sisters adopted secular clothes they bought off the rack like everyone else.

How was Corita faring after the chapter of renewal in 1967?

Professionally, there were the commissions and interviews and the continual stream of visitors who would drop in and interrupt Corita's classes, something that annoyed many of her students. Corita was burning out from her work. Cardinal McIntyre's oppressive attitude toward the college and

Corita as a woman religious and IHM sister was a burden. Added to this the fact was that Corita was beginning to question her vocation and her very belief in God.

It was all becoming too much.

Helen Kelley, the former Sr. Mary William, said that Corita was

> widely regarded as a model religious. She was kind, and she was prayerful, and she was helpful, she worked hard at whatever she did, and we borrowed glory from her when she began to be known as an artist. . . . If she had been in any ways difficult, maybe the leadership of the community would not have been so supportive. As it was they said, "You don't get this kind of goodness from a bad person." Maybe they didn't understand her art, or like it particularly, but they said, "Here is a good woman whose work is being recognized."[5]

Mary's Day

Beginning in 1958 the national profile of Immaculate Heart College was on the rise despite its small size. Besides the art department, the Immaculate Heart Trio (the Zeyen sisters, all of whom were IHM sisters) recorded chamber music for Capitol Records, and the theatre arts department often cast local aspiring Hollywood actors. The famed English department of the college boasted published authors, both as a department and as individuals. Officials in the chancery office noticed.

One day Mother Mary Humiliata (Anita M. Caspary), president of Immaculate Heart College from 1957–63 and mother general from 1963–69, was confronted by Cardinal James Francis McIntyre, the archbishop of Los Angeles in a way that did not bode well for the college. She related:

"Do you realize that your college is being criticized in the diocese as liberal?" the cardinal asked. I stood before his oversized desk like a prisoner in the dock. I was startled by his question, and I tried to think of what it might mean. This was in the late fifties. . . . Quite by chance I was in the archdiocesan chancery office having accompanied Sr. Marie Fleurette who was in charge of the drama department. She was producing an Irish play directed by Ria Mooney from Dublin's Abbey Theater. She knew that Bishop Timothy Manning would enjoy the Irish play and had persuaded me to accompany her to the chancery to issue the invitation personally. Bishop Manning received us graciously as always; he promised to attend the performance and then unexpectedly, and somewhat hesitantly, stated that Cardinal McIntyre wished to see me. My companion was to remain in the waiting room outside his office. . . .

"Liberal"? I echoed his word, trying to understand its meaning as applied to the college. My immediate reply was, "I'm not sure, Your Eminence, what you mean by 'liberal.' We are liberal in the sense that Immaculate Heart College is a liberal arts college, but that's very different from being a liberal college."

"You should know what it means," was his response, in a remarkable bit of sophistry. "You are the ones being accused of it, so you are the ones who should give answer to that."

His reply left me stunned. Where were we going from there? His Eminence scarcely paused. He went on to explain that he was concerned particularly with the art department; Sister Corita's colorful new look of religious art was to him, as well as to some traditional Catholics, sacrilegious.[6]

The cardinal did not stop there but went on to say that the college's courses in general were too worldly, accusing Mother M. Humiliata of trying to make Immaculate Heart like secular colleges.

Mother M. Humiliata was so upset by this encounter that she went home and told the mother general, Mother Regina McPartlin, that she thought the college was going to be closed because at the end of the meeting, even as Mother Humiliata sought to counter his accusations, the cardinal said, "If this keeps up, the college will have to close."

Although we don't have Corita's reaction or response to the cardinal's judgment on her art, even to the stalwart among us it must not have been pleasant to hear, especially if her actions were tied to the future of the college.

The cardinal continued to impinge on the college's academic freedom, which is evident from correspondence on file dating to 1966. His control extended to other speakers, philosophers, and theologians—including Hans Kung, Charles E. Curran, Daniel Berrigan, SJ, Philip Berrigan, and others that the college invited or wanted to invite.

Back in 1961 Sr. M. William (Helen Kelley) had asked Corita to help with the planning of the traditional Mary's Day celebration, and in 1964 asked her to take over its direction. Held every May for decades, it consisted of a day dedicated to honoring Mary, the Mother of God, with Mass, a solemn rosary procession winding up the hill in the evening to the college, and ending with the crowning of Mary in the evening by a specially chosen student. The students usually dressed in academic caps and gowns, but the new generation had not been responding well to the traditional day. Anita M. Caspary describes the 1964 Mary's Day: "Crepe-paper flowers, streamers, and banners fashioned by the students in the art department decorated the grounds, the visual representation of a new tradition honoring Mary. The bravest of the sisters even decorated their dark habits with bright garlands. Modern songs were adapted to fit the theme of the day, accompanied by guitars played by the students."[7]

Corita understood that Mary's Day had originated in another time and circumstances. "I was commissioned to make the day new. . . . Our [hers and the students] celebration grew out of a desire to make Mary more relevant to our time—to dust off all the habitual and update the content and form."[8] By 1964 Corita decided to "celebrate the real woman of Nazareth."

Much excitement accompanied the preparation for the day, even from students from other departments. A Market Basket supermarket had opened up across the street from the school, and students asked for the big posters advertising food and products, which the store generously gave them. The theme of that Mary's Day was "Peace on Earth"—food and peace, food for the poor and hungry. The students brought food for the poor and carried the store's posters in procession. Scenes from this Mary's Day are included in the short documentary film by Baylis Glascock, *Corita on Teaching and Celebration.*

Almost everyone was pleased with how the day turned out, with the press and television covering the event as well. The cardinal, however, was not happy about the new Mary's Day, but he did not object then. Some of the sisters, however, were upset that the Mary's Day tradition had changed and voiced their complaints to the cardinal.

The newly founded *National Catholic Reporter* ran an article by Lucia Pearce (later Capacchione), one of Corita's former students who would go on to work for Charles Eames and Disney. The article titled, "Sister Corita: Bringing Art into Learning," accompanied a write-up of the Mary's Day celebration. The caption to a photo looking down onto the altar reads, "With food and peace as the theme of Mary's Day at Immaculate Heart College, there could be no more fitting climax than a colorful, jubilant celebration of the ultimate banquet, the Mass."[9]

Kenneth Woodward, *Newsweek*'s religion editor, wrote that the 1964 Mary's Day was a "religious happening."[10] In the sixties, "happenings" were a living, moving fusion of visual art, performance, and music. Corita's new Mary's Day had all of these elements, plus liturgy and the joy and excitement of the participants.

Two years later, however, Mother M. Humiliata, now the mother general, was asked to explain Mary's Day 1966 to Auxiliary Bishop John J. Ward who wanted to know more about it and the extensive or "overzealous" publicity it received. Mother replied by mail to the bishop's letter, explaining that the liturgical celebration, presided over by Fr. Mark Kent, MM, Corita's brother, the previous year (e.g., how communion was distributed) had been resolved and she had been present this time to make sure everything went well. The cardinal, however, responded to Mother's letter personally. He did not accept Mother's explanation because his own sources contradicted her. After reminding her that everything pertaining to the liturgy and religious art fell under his jurisdiction, he moved on to Corita: "May I say further, that we hereby request again that the activities of Sr. Carita [*sic*] in religious art be confined to her classroom work and under your responsibility. You are reminded of the restrictions in this regard issued last year. Any other project that sister Carita [*sic*] may indulge in will have to be submitted to the Committee on Art . . . for approval."[11]

What restrictions was the cardinal referring to? In 1959 Cardinal McIntyre had written to Mother Regina, the mother general, that Corita and the art department "refrain from representations of our Savior and Our Lady and the saints that are not obviously reverential. Figures that are burdened with a large element of uncertainty, as well as of the grotesque, are disturbing to pious souls, not excluding Religious."[12]

The Catholic Artist

While Corita's responses to these judgments are not documented, it is enlightening to consider a brief paper that she presented on the philosophy of art in 1958 at the Vatican-chartered Catholic University of America. Perhaps if Cardinal McIntyre or anyone at the Los Angeles chancery office had bothered to read it when it was published by the university the following year, this thoughtful paper might have mitigated or influenced how Corita's critics in church circles judged her art and role as a teacher, as well as her community and the Immaculate Heart College then and in the decade to come.[13]

Corita and Sr. Magdalen Mary were invited to take part in a workshop at the Catholic University of America in Washington, DC, on June 13–24, 1958. The theme was "On New Trends in Catholic Art Education." The title of Corita's paper was "The Philosophy of Art Education."

Corita spoke about what a Catholic artist or educator deals with: what is fixed and unchanging (dogma and principle) and what is moveable and changing (reality and art). The paper reveals Corita's deep thinking about philosophy and the meaning of the words *Catholic, education*, and *art*. Her approach is semiotic, exploring the relationships between words as signs and their meanings and challenging the literal minded.

The initial example she used in presenting her paper was the introit, or opening antiphon, of June 24, the Mass of St. John the Baptist's Birth (now called the Solemnity of the Nativity of St. John the Baptist): "My utterance is a sword he has been keeping, ready sharpened . . . here is an arrow he has chosen out carefully."

> *Moveable*—Words are called swords and man is called
> an arrow. As this is an artistic, a poetic way of speaking,

the writer is free to call things whatever he pleases to achieve the end of his poem.

Fixed—A poem is believed as a poem. A poem is judged by the principles of poem-making. A poem is not judged by comparing it with something it is not, i.e., saying this is a bad poem because St. John is not actually an arrow.

This is fixed because it has to do with principle—a thing must be judged with concern for its own mode of being. . . .

A photograph has qualities of abstraction, and a painting has qualities of abstraction, and scriptural language has qualities of abstraction. This is a property of any work that engages in subject matter other than itself. If the whole thing were present (with no abstraction), we would have that thing and not the art piece. The art piece is simply another thing with its own reality which answers to its own principles, not to those of some other form of being.[14]

Sabbatical

It was obvious to those who knew her that something was up with Corita. As the summer of 1968 approached, after a year of change in the community, Corita asked for and received permission for a sabbatical for six months with the possibility for another six months. As she said many times, "It had all become too much."

Corita spent much of the 1967–68 school year at the house in Montecito, going into Los Angeles to teach classes at Immaculate Heart. She wore the modified habit and then secular clothes. She wrote to her friend, Fr. Joe Pintauro, and their correspondence became darker and darker; they were both going through a time of trial and discernment, and for Corita, discouragement, but what was of more concern was the depression she was feeling. She wrote to him, "I'm really frightened to say this but everything appears

different to me, even God, and I'm so afraid that I am losing the foundation of my belief."[15]

On the back of a print she had made, she penned a quote to Joe from the Italian playwright Ugo Betti (1892–1953): "To believe in God is to know that all the rules will be fair and there will be wonderful surprises." Corita was a believer and always loved the surprise element of life in the classroom so her next sentence is deeply revealing about her state of mind: "Fall is coming and I can't see it."

Betti's quote became the inspiration for the Harper & Row book *To Believe in God*, written by Joe and illustrated by Corita. Toward the beginning, Joe's words on Corita's black-and-white pages say, "To believe in God is to get high on love enough to look down at your loneliness and forget it forever." The last two-page spread reflects the ambiguity they both seemed to be struggling with. The words "To believe in you is more than I need to make believing more than making believe" are over a multicolored page with the big lettered words that Corita does not finish but seem to say: THE MA[N].

Several IHM sisters left the community during that time. To Liz Bugenthal (the former Sr. M. Fleurette) the contradictions between what was expected of the sisters as professional women and as religious became too burdensome. The institutional church in Los Angeles had become too uncomfortable. For example, when the sisters would need to go out at night for meetings or wanted to hear speakers to keep up their professional development, Cardinal McIntyre made this difficult because he said they were to keep the 10:00 p.m. lights out rule. When they asked to have an evening Mass to accommodate the older sisters, the cardinal said there was to be only one Mass a day—in the morning—for all the community, therefore he did not grant leniency for

the elderly. Cardinal McIntyre was very much a man who believed that if you followed the rules and did what you were supposed to do everything would be fine. Although McIntyre may not have been the only prelate uncertain about the implementation of Vatican II, his attitude left little room for creativity for the sisters to grow as women and disciples of Jesus and to respond to the signs of the times.

Amidst the inner and outer turmoil of the community with the local church and her personal inner conflict, spurred on by recurring depression and discernment about leaving the community, Corita still took time to listen to and encourage teachers. When asked, she made the time to listen to them. She kept a full schedule of travel, exhibitions, and students' shows, but those around her knew how exhausted she was.

In that year before she went on sabbatical, Corita began seeing a Jungian psychologist, a practice she continued for the rest of her life.[16] According to Celia Hubbard (an artist friend from Boston), it was through Jungian dream analysis that Corita was able to see a way forward and recognize that she did want to leave the community and marry.[17]

Hubbard accompanied Corita to the 1967 Expo Montreal (the World's Fair). She noticed how tired Corita was. They shared a room, and when Corita took off her habit Celia remembers thinking that Corita was so small and slight that it was the habit holding *her* up. She wrote to Sr. Helen Kelley, the president of the college: "I think Corita may have an exhaustive breakdown if she doesn't take some time off. If you want her to be around she needs a little vacation or sabbatical."[18]

Not long after Corita wrote to Celia and asked if she could stay with her at her place in Cape Cod for the summer. Celia said yes, and so Corita arrived and began making sketches and notes to send to her printmaker, Harry Hambly.

Corita walked the beaches of Cape Cod and loved finding stones shaped like hearts by the ebb and flow of the water. She loved to pack a picnic lunch and supper, the freedom of it all. Her creativity that had waned in her exhaustion was rekindled.

Corita was a sensitive person and she needed rest and a change of pace. Her brother-in-law, Frank Downey, recalled that while Corita always expressed her opinion, she did not share her feelings with many people. She had been living in turmoil for a long time, as had many of the other sisters. It is difficult to ever think of Corita being angry over what was going on with the cardinal, the archdiocese, and finally the Vatican, but she was. Helen Kelley remembers: "I always thought, and Corita somewhat confessed that she was so angry about the previous year and years from so much criticism so out of tune with where the Church was going after Vatican II, and angry that people she loved and admired spent so much time trying to defend attitudes that were right and having this time wasted by a close-minded Archdiocese. Rome should have stood behind its own proclamations and told Cardinal McIntyre to let them be, but the Church did not do that."[19]

Even before her sabbatical was finished, Corita quietly asked for and received a dispensation from her vows in November 1968. She had never owned a personal bank account, paid bills, or driven a car. She had just turned fifty years old and was about to start a new phase in her life.

At the end of the summer, Corita moved in with Celia Hubbard across from the Botolph Gallery in Boston's Back Bay neighborhood. Celia's front room became Corita's studio.

Two years later Corita got her own apartment in a brownstone in the same area, and it would remain her home for the rest of her life.

CHAPTER SEVEN

Heart of the World

"Man in the coming age will be a learning animal."
—*Footnotes and Headlines:*
A Play-Pray Book, 1967

Margaret Rose Welch, an Immaculate Heart sister who knew Corita well, wrote that one of the main things Corita always taught her students was "to find spiritual meaning in the contemporary world, the needs of the contemporary world, the search for meaning and God in the contemporary world. . . . Jungian psychology was a way of deepening her own understanding. . . . Some never understood it was a spiritual search. . . . Regulated practices of Christianity trying to limit God, she didn't want that. Her own understanding looks to the cosmic presence of God, versus [a faith] in human institutions."[1]

Daniel J. Berrigan, SJ, remained her friend always. He expressed Corita's discernment process this way: "Her process had continuity, not just shedding her skin or renouncing vows, but a metamorphosis toward what is good and beautiful because it was more fully herself. She integrated

love, hope and community, an understanding that she always brought with her. She never was not a friend, she never gave up on me, that would have been a stranger, but she was always a friend."[2]

Corita's older sister, Sr. Ruth, wrote that part of the reason Corita left religious life was because she was a contemplative person who could not do it all—go out to conventions and be the teacher her students needed her to be. Corita wrote to Ruth when she had decided to leave and hoped that her older sister would not be disappointed. Ruth responded that she was not disappointed because it was her life to live.

At least one other former member, Paula Kraus, remembers Sr. Ruth's attitude as highly critical of Corita while she was in community, but once she left, Sr. Ruth's disposition lightened. Corita just laughed when people told her that Sr. Ruth seemed happier once she left.

Ruth's approach to how women religious should relate to the hierarchy and avoid or resolve issues was decidedly old world: "A woman should be able to get out of a man most anything she wants if she goes about it the right way . . . not to diametrically oppose [but instead] to cajole him to make him think like it was his own idea. If the whole matter were handled differently, if the press had kept out, it would have been settled more easily and more amicably."[3]

Her manipulative approach to resolve conflict sounds like a scene out of the 2002 comedy *My Big Fat Greek Wedding*. Toula (Nia Vardalos), the grown daughter who wants to go to college, complains, "Ma, Dad is so stubborn. What he says goes. 'Ah, the man is the head of the house!' " To which her mother Maria (Laine Kazan) replies, "Let me tell you something, Toula. The man is the head, but the woman is the neck. And she can turn the head any way she wants."

Corita wrote to her friend Joe Pintauro that she was going to sign her artwork differently now, as Frannie Kent or Frances Kent, because she was not a nun anymore. Joe, who would eventually leave the priesthood, was working at an advertising company and knew the importance of branding, even if he didn't call it that. He told her she was the artist "Corita" and he talked her into keeping her name. And so she did, and later thanked Joe for his advice.

She must have felt happier and lighter in spirit now that she had made her decision to leave the IHM sisters, a decisive break that reestablished her across the country. She designed the cover for the *Saturday Evening Post* that closed the old year and opened the new; the theme was happiness (Dec. 28, 1968–Jan. 11, 1969).

After arriving in Boston Corita was invited to teach at Harvard University, but she declined in favor of making art. She managed to collaborate, however, with Harvard theologian Harvey Cox, whom she had met previously during a presentation at Yale. Together they organized "An Evening with God" at a nightclub in New York, and it was so successful that they decided to repeat it at a Boston nightclub called The Boston Tea Party, with Dan Berrigan and folk singer Judy Collins both joining in. Mickey Myers, who says that Harvey Cox was always a good friend to Corita, was involved in both of these "happenings."[4]

As Corita was letting go of some old friends, she made new ones. Judy Collins and Corita remained in touch for years; Collins's phone number is one of the few Corita had in her tiny Hermes pocket address book when she died. That phone book also included such interesting figures as Rabbi Abraham Heschel, Dan Berrigan, Jerry and Carol Berrigan, Harvey Cox, and Kathryn Crosby, the wife of Bing Crosby.[5] It was Kathryn who helped design the modified habit for

the IHM sisters after the chapter of renewal in 1967, and Corita was known to have experimented with the look of the habit as well. That same year Corita designed the cover for Kathryn's autobiography, *Bing and Other Things.*[6]

Corita moved into her own apartment in August 1970, not far from Celia and the Botolph. Celia, who was not much of a cook, wrote down some recipes she had used when she and Corita shared the apartment because Corita wasn't a cook at all.

Corita was invited to be on *The Tonight Show Starring Johnny Carson*, but she told the producers she didn't stay up that late. When the *Today* program asked her to appear, she told them she didn't get up that early. She eventually accepted the invitation to be interviewed by Dave Garroway. Corita's friend Mickey Myers relates that when Garroway introduced her as Sr. Mary Corita she quipped: "My name is Corita Kent; some people can't get rid of an old habit."

Corita liked to accept invitations to lecture and show her work at small venues such as parishes on a Sunday rather than accept big speaking engagements that were never easy for her. Always a teacher, she exchanged the school classroom for that of the world.

Once Corita was on her own, she could go to sleep when she could and wake up whenever. But she was still plagued by insomnia as well as depression, which her closest friends noticed. She was also lonely.

Relationships and Friendships

For a while Corita stepped away from her old friendships and acquaintances from Immaculate Heart, but little by little renewed some of them. Visitors came to her Boston apartment, and she traveled to Los Angeles at least once a year

for exhibitions of her work. She would also check in at the gallery run by her sister Mary Catherine, where she would meet family and friends and sign prints for people.

There is no doubt that Corita would have liked to be married. Mickey Myers relates that she advised Corita that if she wanted to be fashionable and attract a man she should shorten her skirts a little (actually they were Marimekko dresses, designed by the popular Finnish company known for its original and colorful prints), which Corita did. But when the style changed to longer hemlines the following year, she was a little upset at Mickey—now she would have to lengthen them all again but there was no fabric left!

April Dammann, author of the unauthorized biography *Corita Kent. Art and Soul. The Biography*, casts three priests as potential suitors, creating quite the dramatic story. For various reasons, however, her accounts of these relationships are speculative and can be misleading.[7] First, Corita and Sulpician priest Robert J. Giguere (1918–2003), a professor of philosophy and spiritual director at St. Patrick's Seminary in Menlo Park, were good friends for a four-year period in the sixties. It seems they carried on a robust and extensive correspondence as both were going through difficulties and could provide encouragement for one another. Giguere notes that "they recognized in each other a soul mate" and that Corita had a profound need "to come to terms with herself as an adult human being, a Christian, an artist, and how to live that out."[8] Yet there is no indication that anything more than friendship was in play between them. Supposedly Corita wrote dozens of letters to Giguere, expressing fear about the future and love. They remained friends even after Corita left the IHM sisters. Giguere continued in the priesthood and his community, serving as a teacher and chaplain well into old age.

Second, Corita also shared a close friendship with Dan Berrigan, but there is nothing to suggest that there was anything between them that would jeopardize his dedication as a Jesuit priest. If he ever had doubts about his Jesuit and priestly vocation, they do not emerge from the pages of his autobiography. Nor does he mention, surprisingly, his collaborations and friendship with Corita or his admiration for the Immaculate Heart sisters.[9] If he ever contemplated leaving the priesthood as his brother Phil had done, no published source reveals this information.

The most tantalizing of Dammann's conjectures, however, is her assertion that Corita fell in love with Cardinal Humberto S. Medeiros, archbishop of Boston (1970–83). Dammann reached this unlikely conclusion while conducting personal interviews with Corita's friend, one-time student, fellow artist, and Iowan Josephine Pletscher (1918–2013), though details are vague. Dammann did not consult Pletscher's papers, which are archived at the University of Iowa's *Iowa Women's Archives* and most of which, according to the content description, deal with Corita Kent, Immaculate Heart College, and correspondence with Corita's older sister Ruth.[10] It appears that Dammann's claim is based on Pletscher's testimony that Corita was very moved when she spoke of a bishop named "Bert"; Pletscher specifically identified this bishop as Cardinal Medeiros on two occasions, although she provided no evidence.

It seems a big leap to identify a bishop named "Bert" with Cardinal Medeiros. Anyone familiar with these two figures will quickly recognize that their views of the church and the world were very different. The disparity of their outlooks in itself does not disprove anything, of course, but coupled with a significant body of evidence that has recently come to light, it does cast significant doubt on Dammann's allegation.

Monsignor William M. Helmick, now pastor of St. Teresa's Church in West Roxbury, MA, was the secretary for Cardinal Medeiros for all but the first seven months of the thirteen years he was archbishop. He also lived in the same house as Medeiros (the cardinal's residence) in Brighton during that time. Helmick is firm in asserting that he saw and heard almost nothing about Corita from Cardinal Medeiros in all those years, although everyone knew who she was due to her commission from the Boston Gas Company to decorate its huge tank on the Southeast Expressway in 1971.[11] Kathleen Woodward, the receptionist at the residence who welcomed visitors, answered the phone, and handled the mail, also asserts that she neither saw nor heard anything of significance or importance about Corita while Cardinal Medeiros was archbishop.

What is more likely is that Pletcher and then Dammann misidentified "Bert." Corita indeed had a friendship with Norbert F. Gaughan, auxiliary bishop of Greensburg, PA, from 1975 to 1984 and bishop of Gary, Indiana, from 1984 to 1996.[12] Fr. Charles Niblick, a priest of the Gary Diocese and executor of Bishop Gaughan's estate, remembers their friendship as one rooted in a mutual love of art (and not necessarily a romantic love of one another). Gaughan was an artist, and he and Corita painted together when Corita visited him once at his residence at St. Emma Monastery in Greensburg. She designed at least one cover for a commencement speech that he gave (the Corita Art Center has a copy), and the bishop left a significant collection of Corita's art when he died.

Mother Mary Anne Noll, OSB, prioress of St. Emma Monastery, who entered the community in 1962, recalls that Corita visited in 1968 for a week to ten days, at the invitation of the then-Monsignor Gaughan.[13] He served as

the chaplain of the community from 1962 to 1984, even after being ordained as the auxiliary bishop for Greensburg. It was the bishop's idea for Corita to decorate the back wall of the Our Lady of Fatima retreat house chapel after the space had been plastered over. One of his own photographs of a daisy served as the model. He was very devoted to wildflowers, and he made several silkscreen prints of them, often resonating Corita's style by adding quotes to the bottom. Mother Mary Anne, then a sister in temporary vows, was assigned to help Corita paint multiple daisies—exploring both an "eye of God" theme and a symbol of the Blessed Virgin Mary—all over the eighteen- by twelve-foot wall. The work took several days to complete, but it was all painted over about a decade later. Noll also reported that Bishop Gaughan gave their community several of Corita's prints, which they mounted in the hallways and took down after he left to become the bishop of Gary, Indiana.

Although one cannot identify Bishop Gaughan as "Bert" with certainty, he is (at the very least) a more plausible candidate than Cardinal Medeiros. And it remains to be shown whether the relationship involved anything more than mutual aesthetic interests. To be sure, Corita never developed any of her relationships to join in the bonds of marriage. One can only imagine the longings of her heart for companionship and love.

The Church

There was a maple tree that grew outside her apartment window that Corita loved. She contemplated it during the changing seasons and it became an old friend. She used it often in her art.

I keep on looking at the maple tree outside. I moved to this place in October and the tree was in full leaf then. I watched it lose its leaves, I watched it covered with snow. Then these little green flowers came out and it didn't look like a maple tree at all. Finally the leaves were recognizable as maple leaves and that is very much how I feel about my life. It seems a great new stage for me—whether it will ever be recognizable by anyone else I don't know, but I feel like great new things are happening inside of me. And I know these things have a way, like that maple tree, of finally bursting out in some form.[14]

When Corita quietly left the Sisters of the Immaculate Heart of Mary, she also left the Catholic Church. She was on a journey of personal growth and of discovery. In a conversation about Corita that I had with a former IHM sister and now a member of the IHM Community in Los Angeles, she told me, "She just walked away."[15] There was no door slamming. Helen Kelley affirmed that Corita loved the IHM sisters and would never have done anything to embarrass the community. In several interviews with the press over the next few years, journalists would ask Corita about her no longer being a sister or a Catholic, and she would quietly respond, "It had all become too much."

By the eighties Corita had moved beyond what she saw as the boundaries of the Catholic Church and was no longer at home with the Christian way of defining how the world works. But those who knew her called her spiritual, holy, and, in the view of Lenore Dowling, a mystic. There was much in Christian terminology that no longer had meaning for her. "God is a total mystery, and that's it," she told a journalist.[16] Around the same time she also said that she believed more and more strongly in Christian principles and in the faith like of young children, a God without limits.

She said in one undated interview with Sandra Gilligan Connell in the eighties that she had had her time with institutionalized religion and now liked to have a broader view that included all people and drew on all areas of religious thinking and sources. This included reading about science and physics because these disciplines show how everything and everyone is connected and interconnected. "I try to get my information aesthetically and artistically rather than dogmatically . . . the greater world comes to us through indirection rather than definition."

This is not a unique way of considering how grace comes to a person, either. Corita's journey brought to mind what the Catholic novelist Flannery O'Connor once wrote, that more people come to the church in ways that the church does not approve.

Reading through many of the interviews that Corita gave during the eighties, one might say that she was a relativist as she strived to achieve her full potential as a human being and, though she does not mention it explicitly, perhaps work through the pain of the past and mature. New Agers might claim Corita. But she was always an artist and, for her, art brought the secular and religious together. In that same interview she said, "I came to feel that there is no distinction between religious art and secular art. Religious means to bind together. Religion is defined as a deep sense of connection to the whole cosmos so that we know we are related to everything and everyone."

Corita also believed that she outgrew the institutional church the same way she outgrew doctors and the government or any institution that wanted to take care of her. She felt that each one had to become mature and take responsibility for himself or herself.

Wholeness is a theme she strived for and lived, making art that would unite the fractured and broken symbols of daily life. When all the elements of a work of art came together it reflected the wholeness of the universe, and this she believed reached people on a spiritual level. "Art," she told Gilligan, "is to alert people to the things they might have missed. Out of all the apparently evil, dark, and painful stuff, our job is to make flowers grow."

Corita then described herself as a human being, living like one and having all those values, and behaving as a human being as opposed to being and acting inhuman.

Art and More Art

From the seventies almost until her death, Corita had work, either commissions or creating her own art. She also morphed at that time from pop art serigraphs to painting first with primary colors and then watercolors.

In 1971 Corita received a commission from the Boston Gas Tank Commission that resulted in the largest copyrighted work of art in history. As part of an effort to spiff up the city, Boston Gas wanted Corita to design something for both tanks on the Southeast Expressway in Dorchester, Massachusetts. She designed a swath of primary colors like a rainbow, using a miniature model, and conveyed the concept to the curator and the painters. She went there for two days to watch their progress but left dismayed. Whatever they were doing, it wasn't her design. The painters, who had to work against the wind, revisited the model and finally, though never as perfect as she would have liked, completed the rainbow on the first.

Corita chose the rainbow because it was a sign of hope and God's covenant with humanity. Corita didn't yell or

scream. It can be said that her art points to truth and greater realities, and one wonders if the gas company ever noticed.

The rainbow caused some controversy though; one woman wrote to the *Boston Globe* that she found the face of Ho Chi Minh in the blue swath. Corita thought the woman's response ludicrous.

The president and CEO of Boston Gas, Eli Goldstone, who commissioned the tanks, died not long after the first one was completed. His successor believed that covering the second tank with butterflies as Corita had planned would distract from the first so it was never painted. The rainbow tank was actually a great success, which is why when it was torn down in the nineties the design was duplicated on another tank.

Throughout Corita's lifetime her art was exhibited at the New York Metropolitan Museum, the Museum of Modern Art in New York, and many other venues. In 1980 the DeCordova Sculpture Park and Museum in Lincoln, Massachusetts, came up with the idea for a retrospective of Corita's work. It was very successful, showing some of her work going back two and three decades. Corita's conviction that her art be accessible and low-priced caused some museums and galleries to undervalue her work at the time, but today her works reside in museums and private collections all over the country and the world.

In her later years Corita created pieces for Amnesty International and a billboard campaign sponsored by Physicians for Social Responsibility: We Can Create Life without War. It came about as a response to the 1983 ABC network television film *The Day After,* about a postnuclear event and its effect on a community in Kansas. Corita studied the nuclear weapon situation and listened to the concerns of these physicians. Billboards with "We can create life without war"

dotted highways in southern California, Indiana, Massachusetts, and Maryland. Corita said it was the most religious thing she had ever done to that point.

Corita was a person who watched television, though she lamented that people didn't seem to think critically about what they were watching. And she loved movies. When she became ill, one of the things she liked to do was to go out to a film with a friend.

In 1983 the US Postal Service contracted Corita to make a design for a stamp with a rainbow. She sent several versions to the committee that chose one, but the postmaster general rejected it. This devastated Corita. But four years later the "Love" stamp was approved and printed, and a giant version of it was lowered in front of sixty-five thousand people in Washington, DC, on December 31, 1984. The stamp was launched (first day of issue) on the set of the popular television show *The Love Boat* in April 1985. Corita was invited but she refused to attend, as she was furious about the venue. The meaning of love for Corita was the kind that brought people around the world together, so much more than what the hour-long show represented.

CHAPTER EIGHT

Heart of Love

"Love is hard work."
—1985

In 1974, at the age of fifty-six, Corita was diagnosed with ovarian cancer. She consulted doctors in Boston and Los Angeles and embarked on an intentional regimen of exercise and a gluten-free diet well ahead of the nutrition trends of the twenty-first century. According to Dan Berrigan she meditated and used guided imaging (the Simonton visualization method for combating cancer). He also said that Corita was supported by a circle of friends who embraced her and that she had a new connection to the circle of earth on which she stood. She had surgery in Los Angeles, and her sister Mary Catherine took care of her afterward. Mary Catherine and Frank were devoted to Corita. She was very optimistic about her prognosis after that first surgery, but at least one friend thought Corita hadn't quite grasped how serious her situation was.

After Corita returned to Boston following surgery, Mickey Myers would call and ask how she was, and Corita would respond, "Rotten."

Corita also had surgery in 1979 for a polyp in her colon that was cancerous. Corita's world was upended when her dear sister Mary Catherine, who had always cared for Corita, was diagnosed with cancer that same year. Now they both went on a special nonwheat diet of mostly nuts. The two sisters and Frank were even able to take a trip to Europe one summer. Corita was so worried about food, almost obsessive about it, that she took along twenty-five pounds of nuts. Once her anxiety over what she would eat was assuaged, she was able to enjoy the trip.

Most summers, however, Mary Catherine, Frank, and Corita went to Maine where Corita would paint watercolors in the morning and Frank would mail off prints in the afternoon. After her diagnosis with cancer, Corita found comfort in the softness of watercolors. During the year, Mary Catherine ran Corita Prints, the gallery that she and Frank had started together in Los Angeles. Marlene Teel-Heim, a friend and gallery owner in the San Francisco Bay area, knew Mary Catherine from the gallery and thought she was warm and friendly whereas Corita's personality was more reserved.

Although Corita and Celia Hubbard had a falling out when Celia told Corita she thought her work was below par, Corita kept painting. It seemed that her style reflected the geography of her new home in Boston, dealing with cancer, her insomnia, and efforts to overcome the depression that hung over her. She sought wisdom from faith healers and obscure religions. This led to her 1977 *moments* series. She used dried flowers from a card someone sent her as the theme of her drawing and made eleven prints that were all connected if they were laid out side by side. Corita used her own words for the text, the first time she had ever made something completely original from image to text. Beacon Press published the series as a book in 1982 with a foreword

by Norman Cousins, who promoted the "healing through laughter" approach to cancer as well as the connection between emotions and cancer. In 1984 the series was published as a calendar.

One of her painting buddies was her old friend Elinor Mikulka. Even though Corita was tired and would take breaks, she still painted with a quick intensity. The last watercolor Corita painted was on a trip to Hilton Head Island, South Carolina, with Elinor and her husband Charlie.

When Mary Catherine died, Corita was devastated. She made several prints in memory of her sister, writing on them, "flowers grow out of dark moments." For the next several years after Mary's death, Corita and Frank still traveled to Maine for vacation. Mary Catherine had asked each one to take care of the other.

The doctors discovered in early 1986 that the cancer had spread to Corita's liver. Her friends Mickey Myers and Sara Campbell were often with her for doctor visits and chemo treatments. One day a neighbor walked her to the car and told Corita she would win this battle. Corita held up a fist and said she wouldn't win it like that but then opening up her hand, she said "but like this."

The doctors told her the cancer was terminal. Sara Campbell remembers that one day she was so sick from the chemo that she just put her face in her hands and cried. Corita never cried; she found it impossible to cry. But now? They talked about dying, and Corita told Sara that she knew she was going to a better place.

As Corita continued with chemo, her hair began to fall out. She used colored scarves to cover her head. It was hard to eat and speak because of the sores in her mouth.

Corita moved in with Elinor Mikulka and her family, as she could not be on her own any longer. She became so ill

that she went back to Massachusetts General Hospital for awhile. Once she was able to keep some food down, she was released to the care of the Mikulkas and went on hospice care.

One day when Mickey Myers was visiting, Elinor reached out and gently touched Corita's leg in a gesture of comfort. Corita burst into tears. They asked what was wrong, and she said that this is what she had wanted all along, for someone to touch her.

In the 1985 calendar, one of the two included in her papers at the Schlesinger Library, she noted errands: taking out the trash, plants (watering?), sewing, and getting her teeth cleaned. In February she went nine days without a walk, and on February 6 she noted she had "good sleep." On February 20 she had lunch with her sister, Ruth. On March 17 she noted she took an extra walk and tidied up her desk (she had so much correspondence she had to make an effort to keep up; at the college she would make little piles on the floor so she would remember to mail letters or distribute things). On March 19 she watched television all day, and on March 20 did some extra painting.

Her physical decline was clear in the 1986 calendar where there are entries noting that she was painting and taking extra walks. There are notes of pain levels in the margins. Some of the final entries are:

 March 13: Art and chocolate
 March 26: Pain
 March 27: Washed out
 March 28: Painting
 April 7: Dr. Mass General. Rest
 May 19: 104 lbs.
 The last entry was for May 20: Sharp pains waist-abdomen

She spoke to Norman Cousins during that time, and he remembers that she talked about everything but her own illness. She was particularly interested in the work he was doing at UCLA Medical School and his findings on the "power of faith, hope, belief and love. That these were not just philosophical abstractions but physiological results, that there is no separation from creativity and spirituality. She gloried in the fact that science now verified what she always knew to be true."[1]

In August a friend called Dan Berrigan and told him Corita was in the hospital. He said,

> It was so grim this time that I thought, I must get to Boston. She had survived the surgery, lost considerable weight, even from that destitute little frame. I found her in a tiny room of an old wing of the hospital. When I came in unannounced, bearing a flowering plant, she broke out weeping. "You make me cry," she said through tears. (She had said to a friend some time before, "Oh if only I could weep.")
>
> I said, "I hope you won't have that put on my tombstone, 'I make my friends cry!'" Then she laughed.
>
> We had a good hour together. She was weak as a newborn, but perked up wonderfully for the occasion, very much herself propped there on pillows, with her own art on the walls, undoubtedly the most cheerful thing her friends could come upon.
>
> We talked and reminisced and wandered far afield in time, calling up friends, occasions, the dreadful years of war when our only recourse, it seemed, was to "have a party" and the only reason to announce one was to plan another.
>
> That was the last visit. A day or two later she signed herself out of the hospital, and friends took her into their home where she died ever so gently. She left instructions: no funeral. Her friends, she wrote, might decide to gather for a party, that would be just fine.
>
> East Coast and West, they did.[2]

Corita was cremated at Mt. Auburn Cemetery in Cambridge, Massachusetts, and her ashes scattered in the front yard of Mary Catherine and Frank's home in Los Angeles where Mary Catherine's ashes also had been scattered.

Her statement to her friends read: "I wish to thank my family and friends, known and unknown, who have had a part in forming my life up to this point, and to ask that by your prayers and thoughts you continue to help me in the new life I begin now. I feel this new life is just a next step and that I will be knowing and caring for all of you forever. With love and hopes for your futures, Corita."

Concluding Thoughts

During her lifetime Corita created almost eight hundred serigraph originals, thousands of watercolors, and countless commissions, both public and private. The Corita Art Center in Los Angeles has the largest collection of Corita's art and related materials. In addition to the comprehensive collection at the Hammer Museum, also in Los Angeles, Corita's art is included in the collections of at least fifty-five museums in fifteen states and Washington, DC, as well as in Canada, France, Germany, New Zealand, and Australia.

Corita's art is a remarkable accomplishment and gift to humankind. I think to understand Corita Kent's journey, one must understand the experience of religious life for women in the twentieth century. Much of Corita's early years in the convent were similar to my own as my community took renewal much slower, make that much, much slower. It is good to recall that there was not much discernment or vocational guidance before entering religious life until after Vatican II.

When Sr. Ruth says that Corita and the others should have known how to finesse a churchman, I remember our

Italian-born Mother Paula Cordero (1908–91), who started the Daughters of St. Paul in the United States, saying, "If you want to get what you want from a bishop all you have to do is feed him well!"

It may be true that this is how the feminine manages the masculine, but it's not who the women religious are—those who went through Vatican II and the ecclesiastically turbulent years that followed. Someone asked Corita once if she was for women's liberation. She said she was, but that this is how she had been living her life for years—as a woman.

There comes a time in the life of any woman religious that the real moment of decision arrives, and it can come long after final vows. It can be a journey that takes years especially if one does not discern well early on. But at some moment, one says "yes" definitively to God—not to a superior, or a community, or a job—not to anyone but God. Or one says "no" that this is not the way for me; I must keep searching for what God is asking of me and sometimes I must keep searching for God, for meaning.

I think there are many people today who are pilgrims like Corita who journey in the mystery of God.

Some believers dismiss or look down on those who doubt or who quit what looks like the straight and narrow road to walk a crooked one—or one that looks crooked to them. Just before Mother Teresa of Calcutta was canonized on September 4, 2016, Jesuit Fr. James Martin told Religious News Service in an interview, "The great irony is that this most traditional of saints becomes the patron for people who doubt, people who seek, people who are agnostic. She becomes the 'Saint of the Doubters,' which no one would have suspected during her lifetime."[3] Who would have ever thought that both Mother Teresa and Corita were going through similar journeys along different paths at the same time?

Flannery O'Connor writes in one of her letters that "I think most people come to the Church by means the Church does not allow."[4] This was true of Charles Péguy (1873–1914) who once wrote: "The sinner is at the very heart of Christianity. Nobody is so competent as the sinner in matters of Christianity. Nobody, except the saint."[5]

In an interview in *Psychology Today* in 1970, Harvey Cox, another friend of Corita, said that the art of Corita Kent was "enormously important . . . with her paintings, she lets us say that man's creations, even the venial ones, are sacred" and that Corita's sacramentalizing art "humanized the environment and reminds us that the world . . . is unfinished."[6]

Harvey Cox refers to Marshall McLuhan in that same interview, who taught that "if something fills our whole environment, we cannot see it." God filled Corita's environment through her art, and even if she did not always see it, we can.

Corita's gift was that she juxtaposed ordinary images, slogans, and words that pointed to the ironic, yes, but to greater, transcendent realities.

We trust that she is at home with God, the greatest mystery of all.

Corita read voraciously throughout her life; that she was able to integrate the incarnational theology underpinning *Gaudium et Spes* (Pastoral Constitution of the Church in the Modern World), the final document of Vatican II published in 1965, into her art in the sixties is nothing short of prophetic. She knew that the arts were and are essential to theology, mission, and spirituality going forward.

Yet Corita walked away from the church.

One could make the argument that Corita did have a breakdown, that she was exhausted from the years of nonstop, sometimes frenetic, work, insomnia, extreme criticism

from the hierarchy about her art, and the community she loved, and that perhaps there was something more profound in her psyche that needed to be addressed. Certainly loneliness seems to have been a factor that she believed marriage could resolve. She did say somewhere that living in an institution can stifle the search for meaning, that something like "group think" impedes freedom.

Maybe she left the convent and the church to save her life. She certainly left to find and develop her own sense of self. Spirit builds on nature. She had jumped from being a high school girl into the convent. She wanted to do it. No one forced her. But you can get carried along if you don't ask questions, if you like what you are doing and no one challenges you. When someone challenges you, and it is someone in authority, and your friends get hurt, doubt and questions can enter in.

You can run on fumes of the spirit for only so long.

Corita powered through everything. She was an introvert in a teaching order. She was small but mighty. She became an artist, something she admits might never have happened if she had not become a sister. To be true to herself she made the decision to leave the Immaculate Heart of Mary sisters and the church.

After learning so much about Corita, I believe that even if Corita did walk away, neither God nor her community walked away from her. Her sense of color and playfulness with words delights me. Her sacramental vision that created so many visible signs of invisible grace inspires me. Her unique way of finding beauty in the language of advertising—while subverting it with irony and design to turn it into something new with meaning that transcends the ordinariness of it all—is compelling and deserves our attentive respect.

She loved the lay Christian Immaculate Heart Community that came into being after she was dispensed from her vows.

In her will she left everything to the community, all of her art and all that would be derived from her art—support for her sisters and the community, inspiration for the world that needs messages of peace, choosing to make life not war, finding God in ordinary things and beauty in what is ugly, living with mystery, bringing the secular and the spirit together, and striving to be free.

Corita teaches us to find love, joy, and grace in everything and everyone, even amid inner struggles. To see the connections between the sacred and the secular, to be involved in society in whatever way we can, to care, and to make art because we are all artists. Art is not the same as dogma; art is something that points to something else. Art is not the thing it represents; knowing this makes all the difference.

Corita's beliefs about art are the stuff of gentle revolutions of the heart.

Most books about Corita headline the motto of the Immaculate Heart College's art department, a saying of the people of Bali:

> We have no art. We do everything as well as we can.

Notes

Introduction—pages 1–5

1. *Tidings*, October 10, 1947.
2. Flannery O'Connor, *The Habit of Being: Letters of Flannery O'Connor*, ed. Sally Fitzgerald (New York: Farrar, Straus and Giroux, 1988).
3. Ian Berry and Michael Duncan, *Someday Is Now: The Art of Corita Kent* (New York: DelMonico Books Prestel, 2013), 70.

Chapter One: Little Heart—pages 6–10

1. Corita, 1918–86. *Papers of Corita*, 1936–2015 (inclusive), 1955–86 (bulk), Schlesinger Library, Radcliffe Institute, Cambridge, MA.
2. Corita Kent, interviewed by Bernard Galm, Oral History Program, 1977. Transcript.
3. Ibid.
4. *Papers of Corita*.
5. Ibid.
6. Ibid.
7. Kenneth Woodward, "The Nun: A Joyous Revolution," *Newsweek* (December 25, 1967): 46.

Chapter Two: Heart in the City—pages 11–20

1. Corita Kent, interviewed by Bernard Galm, Oral History Program, 1977. Transcript.

2. Sasha Carrera, "Corita Kent: The Big G Stands of Goodness," *Los Angeles Review of Books* (August 24, 2015): https://lareviewof books.org/article/corita-kent-the-big-g-stands-for-goodness/.

3. Corita Kent, interviewed by Bernard Galm, Oral History Program, 1977. Transcript.

4. Chronology of Jesuits, Blessed Sacrament Parish, Hollywood, CA: http://www.jesuitparish.com/jesuits/chronology-of-jesuits-gallery /chronology-of-jesuits-list.

5. Correspondence with Rose Pacatte, August 2016.

6. A Sulpician priest, Fr. Adolph Tanquerey (1854–1932), was a noted writer; this book was originally published in French in 1930 and was in common use in novitiates and seminaries through the 1960s.

7. Anita M. Caspary, *Witness to Integrity: The Crisis of the Immaculate Heart Community of Los Angeles* (Collegeville, MN: Liturgical Press, 2003), 25–30.

8. Probably Peter Cotel, *The Catechism of the Vows for the Use of Religious* (New York: Benziger Brothers, 1924).

9. Nan Deane Cano, *Take Heart: Growing As a Faith Community* (New York: Paulist, 2016), 24.

10. Corita Kent and Jan Steward, *Learning by Heart: Teachings to Free the Creative Spirit* (New York: Allworth, 2008), 7.

11. Lee interview, February 8, 2016.

12. Dowling interview, February 9, 2009.

13. Cano interview, July 13, 2016.

14. Before the French Revolution members of religious "orders" lived mostly in cloistered monasteries and took solemn vows, meaning that even if members left, they could not be dispensed from living their vows while men and women religious who took "simple" vows of poverty, chastity, and obedience could be dispensed from their vows and the observance of them. By the time the 1917 Code of Canon Law was published the Catholic Church was already easing up and some religious who requested dispensations from solemn vows were also dispensed from their observance. In the latest revised edition of Canon Law published in 1983 all religious orders and congregations are called "religious institutes" or "institutes and congregations of consecrated life" even if some live in cloisters and take solemn vows

or are institutes of apostolic life, meaning the religious take simple vows and carry out the apostolate outside the convent.

15. It would later become the Sacred Congregation for Religious and Secular Institutes in 1967 and is now the Congregation for Institutes of Consecrated Life and Societies of Apostolic Life.

Chapter Three: Creative Heart—pages 21–35

1. Karl Zigrosser, curator of the Philadelphia Museum of Art, coined the term "serigraph" to distinguish print making from the commercial form of silk screening. Seriography is from the Greek serikos (silk) and graphos (writing).

2. Corita Kent, interviewed by Bernard Galm, Oral History Program, 1977. Transcript, p. 22.

3. Ibid.

4. LaPorte interview, Corita, 1918–86. *Papers of Corita*, 1936–2015 (inclusive), 1955–86 (bulk), Schlesinger Library, Radcliffe Institute, Cambridge, MA.

5. Ibid., 10.

6. Corita Kent and Jan Steward, *Learning by Heart: Teaching to Free the Creative Spirit* (New York: Allworth, 2008), 6.

7. IBM's journal, *Business Machines* (Christmas 1963): 4.

8. Sasha Carrera, "Corita Kent: The Big G Stands for Goodness, *Los Angeles Review of Books* (August 24, 2015): https://lareviewof books.org/article/corita-kent-the-big-g-stands-for-goodness/.

9. Corita Kent, interviewed by Bernard Galm.

10. Corita Kent, "Charles Eames Taught Me," a previously unpublished statement written in 1981 for *Quest* magazine. Original is in the *Papers of Corita*, Schlesinger Library, Radcliffe Institute, Cambridge, MA, and published in *Someday Is Now: The Art of Corita Kent* by Ian Berry and Michael Duncan (New York: DelMonico Books, 2013), 254.

11. Correspondence, September 2016.

12. Dr. Lange was a professor at the college for at least ten years and much respected and loved by her students, according to information provided by Lenore Dowling, August 30, 2016.

13. *Papers of Corita,* undated photocopy.

14. Corita Kent, interviewed by Bernard Galm, 77.

15. Michael Novak, "The New Nuns," *The Saturday Evening Post* (July 30, 1966).

16. Ian Berry and Michael Duncan, *Someday Is Now: The Art of Corita Kent* (New York: DelMonico Books Prestel, 2013), 80.

Chapter Four: Heart of Hollywood—pages 36–45

1. Doyle interview, June 17, 2015.

2. *Friends of Calligraphy* (Winter 1981): 252–53.

3. Corita, 1918–86. *Papers of Corita*, 1936–2015 (inclusive), 1955–86 (bulk), Schlesinger Library, Radcliffe Institute, Cambridge, MA.

4. *Ten Rules for Students and Teachers: Corita on Teaching and Celebration* (Studio City, CA: Baylis Glascock Films, 2007), DVD.

5. Doyle interview, June 17, 2015.

6. Dowling interview, February 9, 2016.

Chapter Five: Heavy Heart—pages 46–62

1. Pope Pius XII, "Counsel to Teaching Sisters" in *Pope Pius XII and Catholic Education,* ed. V. A. Yzermans, 50 (St. Meinrad, IN: Grail, 1957): http://files.eric.ed.gov/fulltext/EJ1006063.pdf.

2. Francis J. Weber, *His Eminence of Los Angeles: James Francis Cardinal McIntyre* (Mission Hills, CA: Saint Francis Historical Society, 1997), 7.

3. Ibid., 11.

4. Ibid., 12.

5. Pope Pius X, "The Oath against Modernism," in *Sacrorum Antistitum*, Motu Proprio against the Dangers of Modernism (September 1, 1910): http://www.papalencyclicals.net/Pius10/p10moath .htm.

6. Weber, *His Eminence of Los Angeles*, 12.

7. Nan Deane Cano, *Take Heart: Growing As a Faith Community* (New York: Paulist, 2016), 45–46.

8. Though his books were never placed on the Index of Forbidden Books (after 1965 no more books have been added to the index), in 1962 the Holy Office cautioned against Teilhard's writings. Recent popes approve, including Pope Benedict XVI and most recently Pope Francis in the 2015 encyclical *Laudato Si'*.

9. Quoted in Cano, *Take Heart*, 46.

10. Darryl Natale, "'Mother Mary Is the Juiciest Tomato of Them All': A Retrospective of Nun-Pop Artist Sister Corita," *032C* (February 21, 2014): http://032c.com/2014/nun-pop-artist-sister-corita-was-the-west-coast-alternative-to-warhol/.

11. Gladwin Dill, "Cardinal McIntyre of Los Angeles, Retired Archbishop, Is Dead at 93," *New York Times* (July 17, 1979): http://www.nytimes.com/1979/07/17/archives/cardinal-mcintyre-of-los-angeles-retired-archbishop-is-dead-at-93.html.

12. Weber, *His Eminence of Los Angeles*, chap. 19.

13. Pope Paul VI, *Perfectae Caritatis*, Decree on the Adaptation and Renewal of Religious Life (October 28, 1965): http://www.vatican.va/archive/hist_councils/ii_vatican_council/documents/vat-ii_decree_19651028_perfectae-caritatis_en.html; *Ecclesiae Sanctae*, Motu Proprio Implementing Four Decrees of Vatican Council II (August 6, 1966): http://w2.vatican.va/content/paul-vi/en/motu_proprio/documents/hf_p-vi_motu-proprio_19660806_ecclesiae-sanctae.html.

14. Cano, *Take Heart*, 55.

15. Ibid., 57.

16. Anita M. Caspary, *Witness to Integrity*.

17. Quoted in Cano, *Take Heart*, 61.

18. Cano, *Take Heart*, chapter 5.

Chapter Six: New Heart—pages 63–79

1. Corita, 1918–86. *Papers of Corita*, 1936–2015 (inclusive), 1955–86 (bulk), Schlesinger Library, Radcliffe Institute, Cambridge, MA.

2. Corita Kent, *Footnotes and Headlines: A Play-Pray Book* (New York: Herder & Herder, 1967).

3. Ian Berry and Michael Duncan, *Someday Is Now: The Art of Corita Kent* (New York: DelMonico Books Prestel, 2013), 71.

4. Julie Ault, *Come Alive! The Spirited Art of Corita Kent* (London: Four Corners, 2006), 122–23n16.

5. Berry and Duncan, *Someday Is Now*, 72.

6. Anita M. Caspary, *Witness to Integrity*.

7. Ibid., 38.

8. Corita Kent and Jan Steward, *Learning by Heart: Teachings to Free the Creative Spirit* (New York: Allworth, 2008), 179–81.

9. Lucia Pearce, "Sister Corita: Bringing Art into Learning," *National Catholic Reporter* (November 4, 1964): 5.

10. Kenneth Woodward, "The Nun: A Joyous Revolution" *Newsweek* (December 25, 1967): 46.

11. Caspary, *Witness to Integrity*, 40–41.

12. Alexandra Carrera quoted in Berry and Duncan, *Someday Is Now,* 42.

13. Esther Newport, ed., *Catholic Art Education: The New Trends: The Proceedings of the Workshop on New Trends in Catholic Art Education* (Washington, DC: Catholic University of America Press, 1959); reprinted in Berry and Duncan, *Someday Is Now.*

14. Esther Newport, *Catholic Art Education;* reprinted in Berry and Duncan, *Someday Is Now*, 252–53.

15. Berry and Duncan, *Someday Is Now,* 81.

16. Some have been critical of the role of psychology in the journey of the IHM sisters, but Anita M. Caspary takes on these criticisms, addressing the context and role of psychologist Carl Rogers, whose work with the IHM revolved around communication and change. She roundly refutes the role of Dr. William Coulson, who has named himself a key figure in the "destruction" of the IHM sisters. While he was part of the workshops carried out at the college he never superseded the role of Rogers. See Caspary, *Witness to Integrity*, 239–41.

17. Berry and Duncan, *Someday Is Now,* 81.

18. Ibid.

19. Ibid., 82.

Chapter Seven: Heart of the World—pages 80–92

1. Ian Berry and Michael Duncan, *Someday Is Now: The Art of Corita Kent* (New York: DelMonico Books Prestel, 2013), 83.

2. Ibid.

3. Ibid., 158.

4. Ibid., 82.

5. Mickey Myers said that Corita had a big phone book with many more contacts but this is not in her personal papers.

6. Kathryn Crosby, *Bing and Other Things,* (New York: Meredith Press, 1967).

7. A reviewer of Dammann's book also questions the trustworthiness of these accounts. See Barbara Curtin Miles, "Art with Heart," *America* (October 26, 2015): http://www.americamagazine.org/issue /culture/art-heart.

8. April Dammann, *Corita Kent. Art and Soul. The Biography.* (New York: Angels City, 2015), 121. There is no source provided for this quote.

9. Daniel Berrigan, *To Dwell in Peace* (San Francisco: Harper & Row, 2007).

10. Josephine Marie Pletscher papers, Iowa Women's Archives, The University of Iowa Libraries, Iowa City. http://collguides.lib .uiowa.edu/?IWA0913.

11. William M. Helmick, phone conversation with Rose Pacatte, August 5, 2016; email, September 10, 2016.

12. Helen Kelley, intervies by Rose Pacatte, October 21, 2015.

13. Mary Anne Noll, interview by Rose Pacatte, September 9 and 12, 2016.

14. Pamela Rothon, "A Conversation with Corita Kent," *The American Way* (November 1970).

15. 2016.

16. Mary Bruno, "Portrait of an Artist," *Newsweek* (December 17, 1984): 14.

Chapter Eight: Heart of Love—pages 93–102

1. Ian Berry and Michael Duncan, *Someday Is Now: The Art of Corita Kent* (New York: DelMonico Books Prestel, 2013), 169.

2. Daniel Berrigan, "The Colors of Corita Kent," in *Come Alive! The Spirited Art of Corita Kent* by Julie Ault (London: Four Corners, 2006), 115–16.

3. David Gibson, "Mother Teresa is 'Saint of the Doubters,' says Jesuit Author," Religion News Service (August 31, 2016): http://religionnews.com/2016/08/31/mother-teresa-is-saint-of-the-doubters-says-jesuit-author/.

4. Flannery O'Connor, *The Habit of Being: Letters of Flannery O'Connor*, ed. Sally Fitzgerald (New York: Farrar, Strauss, Giroux, 1979), 93.

5. Charles Peguy, "Un Nouveau Théologien," in *Basic Verities: Prose and Poetry*, ed. Ann Green and Julien Green (New York: Pantheon, 1943).

6. Harvey Cox and George T. Harris, "Religion in the Age of Aquarius: A Conversation with Harvey Cox and T. George Harris," *Psychology Today* 3 (1970): 45ff.

Bibliography

Print

Ault, Julie. *Come Alive! The Spirited Art of Corita Kent*. London: Four Corners, 2006.

Berrigan, Daniel J. *To Dwell in Peace: An Autobiography*. San Francisco: Harper & Row, 1987.

Berry, Ian, and Michael Duncan. *Someday Is Now: The Art of Corita Kent*. New York: DelMonico Books Prestel, 2013.

Cano, Nan Deane. *Take Heart: Growing As a Faith Community*. New York: Paulist, 2016.

Caspary, Anita M. *Witness to Integrity: The Crisis of the Immaculate Heart Community of Los Angeles*. Collegeville, MN: Liturgical Press, 2003.

Dackerman, Susan, ed. *Corita Kent and the Language of Pop*. New Haven, CT: Yale University Press, 2015.

Dammann, April. *Corita Kent. Art and Soul. The Biography*. New York: Angels City, 2015.

Kent, Corita. *Footnotes and Headlines: A Play-Pray Book*. New York: Herder & Herder, 1967.

Kent, Corita, and Joe Pintauro. *To Believe in God*. San Francisco: Harper & Row, 1967.

Kent, Corita, and Jan Steward. *Learning by Heart: Teachings to Free the Creative Spirit*. New York: Allworth, 2008.

Weber, Francis J. *His Eminence of Los Angeles: James Francis Cardinal McIntyre*. Mission Hills, CA: St. Francis Historical Society, 1997.

Film

Alleluia: The Life and Art of Corita Kent: the '60s. Directed by
Thomas Conrad. Los Angeles, CA: Corita Art Center, Im-
maculate Heart Community, 1969. DVD (2014), 23 min.
Primary Colors: The Story of Corita. Directed by Jeffrey Hayden.
Alexandria, VA: PBS Video, 1990. Videocassette (VHS),
58 min.
*Ten Rules for Students and Teachers: Corita on Teaching and
Celebration.* Directed by Baylis Glascock. Studio City, CA:
Baylis Glascock Films, 2007. DVD, 38 min.

Interviews

Cano, Nan Deane. Interviewed by Rose Pacatte, July 13, 2016,
Los Angeles, CA. Audio recording.
Doyle, Joan. Interviewed by Rose Pacatte, June 17, 2015. Corre-
spondence.
Dowling, Lenore. Interviewed by Rose Pacatte, February 9, 2016,
Los Angeles, CA. Audio recording.
Kelley, Helen. Interviewed by Rose Pacatte, October 21, 2015,
Los Angeles, CA. Audio recording.
Kent, Corita. Interviewed by Bernard Galm, UCLA Oral History
Program, 1976. Transcript.
Lees, Hermine. Interviewed by Rose Pacatte, February 8, 2016,
S. Pasadena, CA. Audio recording.
Noll, Mary Anne. Interviewed by Rose Pacatte, September 9 and
12, 2016, by phone.

Index